HUMANE ECOLOGY

ECOLOGY

Eight

Positions

HUMANE ECOLOGY

Eight Positions

Robert Wiesenberger, with essays
by Risa Puleo and Alena J. Williams

Clark Art Institute
Williamstown, Massachusetts

Distributed by Yale University Press
New Haven and London

CONTENTS

FOREWORD

The Clark Art Institute is proud to present *Humane Ecology: Eight Positions*. The works and essays that appear in this catalogue offer insight into and inspiration for the relationships between humans and their changing environments. Indoors and out, the eight artists in the exhibition have intervened in unexpected and compelling ways: murals extend across the gallery spaces, life-size alligators appear on a terrace, hanging seashells form a sound installation, and an artist's garden takes root on a green roof. Refracted through the different geographies and experiences of the artists, these and other works suggest the inseparability of human and environmental concerns.

Environmental questions are of great interest to us at the Clark, given our location among the mountains, forests, and meadows of the northern Berkshires. The campus is designed to complement this natural setting, but our relationship to it is more than aesthetic. The Clark's strategic plan prioritizes stewardship of the land on which it sits through sustainability initiatives, public programs, and more. In recent years we have organized exhibitions about landscape and staged projects on the grounds themselves. Understanding the history of this land, and becoming better stewards of it, is an ongoing process and one to which this project meaningfully contributes.

I would like to extend a heartfelt thanks to the eight artists whose thoughtful works animate this exhibition: Eddie Rodolfo Aparicio, Korakrit Arunanondchai, Carolina Caycedo, Allison Janae Hamilton, Juan Antonio Olivares, Christine Howard Sandoval, Pallavi Sen, and Kandis Williams; their "positions" guided and informed all of our thinking as this exhibition took shape. Thank you to Robert Wiesenberger, curator of contemporary projects, for conceptualizing and organizing this show and for his commitment to vital ecological conversations. Finally, I wish to acknowledge Denise Littlefield Sobel for making this exhibition possible, Maureen Fennessy Bousa and Edward P. Bousa for their major support, and Girlfriend Fund for their additional support.

—Olivier Meslay
Hardymon Director

ACKNOWLEDGMENTS

The Clark Art Institute sits on the ancestral homelands of the Mohican people. We acknowledge the tremendous hardship of their forcible removal from these homelands by colonial settlers. A federally recognized Nation, they now reside in Wisconsin and are known as the Stockbridge-Munsee Community. We pay honor to their ancestors, past and present, and to future generations by committing to build a more inclusive and equitable space for all.

...

This project would have not have been possible without the hard work and good judgment of the Clark's outstanding staff. In particular, I would like to thank the Exhibitions team of Nathan Ahern, Paul Dion, Tom Merrill, Kathleen Morris, Teresa O'Toole, Jessica Pochesci, and Dan Wallis; David Murphy and Anne Roecklein in Publications; Daphne Birdsey, April Clay, and Maureen Hart Hennessey in Advancement; Will Schmenner in Public Programs; Carolynn McCormack and Vicki Saltzman in Communications; the Grounds team and its manager Matt Noyes; and John Carson from Information Systems. Many thanks go to deputy director and Robert and Martha Berman Lipp Chief Curator Esther Bell, Hardymon Director Olivier Meslay, and Sylvia and Leonard Marx Director of Collections and Exhibitions Kathleen Morris for believing in this exhibition.

For their research assistance and insights, I am grateful to Williams College Rodgers Interns Benet Y. Ge, Imogen Mandl-Ciolek, and Isabel Kuh and graduate student interns Ella Comberg, Max Gruber, and Christal Pérez. Many thanks to Williams College students Rosemary Kehoe, Benet Y. Ge, and Riku Nakano for assisting with the garden by Pallavi Sen, as well as to Kimberlean Donis, Gelila Kassa, Lucia Sher, and Lulu Whitmore for production assistance of two works by Carolina Caycedo. Additional thanks go to Sarah Rara and the Williams Class of 1960 Scholars Speaker Series.

Many thanks to Mandy Johnson and James Jarzyniecki of JZJN for their exhibition design. Deep thanks to designer Ryan Gerald Nelson, along with Mark Owens, for the publication and exhibition graphics. We extend hearty appreciation to the many fabricators, consultants, and artist studio staff members who contributed to this exhibition: Paul Dion, Sean Grattan, Knowhow Shop, Magnolia Editions, Tom Merrill, Derek Parker, Katie Polebaum, Joel Stern, and Youngbuk Art Services.

Most of all, I want to thank the artists featured here for sharing their extraordinary work: Eddie Rodolfo Aparicio, Korakrit Arunanondchai, Carolina Caycedo, Allison Janae Hamilton, Juan Antonio Olivares, Christine Howard Sandoval, Pallavi Sen, and Kandis Williams. Finally, I would like to thank members of the Stockbridge-Munsee Community for their engagement with this project and its artists.

—Robert Wiesenberger
Curator of contemporary projects

HUMANE ECOLOGY

Robert Wiesenberger

8

The word *nature* has appeared in the title of several exhibitions, and many more programs, at the Clark Art Institute. It's no wonder why: the museum is set in the Berkshire mountains of Western Massachusetts and its collection features outstanding examples of eighteenth- and nineteenth-century European and American landscape paintings in galleries that offer ample views of the hills and meadows beyond.

Yet to speak of nature also implies an outside—a separation, a "not us"—that is difficult to maintain in an epoch defined by human activity (or the activity of some humans) which has left its mark on every part of the Earth (fig. 1). The human/nature dualism is also a pernicious one. This is not just because of Westerners' long assumed "dominion over ... every living thing that moves on earth" (Genesis 1:26), but also because the category of "human" has, for most of its existence, been selectively applied. Historian Jason W. Moore explains that membership in what economist Adam Smith

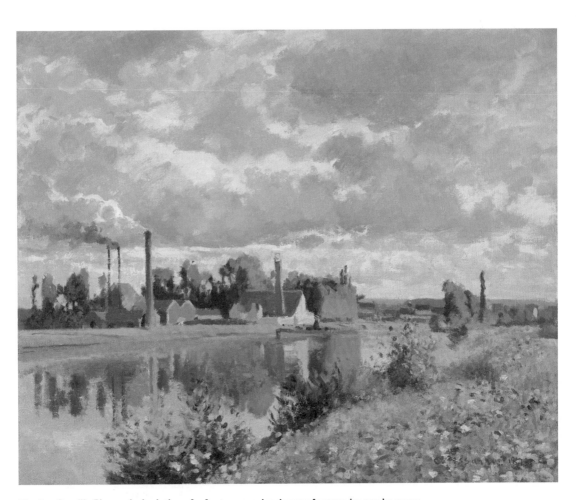

Fig. 1 Camille Pissarro's depiction of a factory as a landscape feature, its smoke merging with the clouds above, was unusual for a French Impressionist. It represents an image of the Anthropocene, an epoch defined by human impact on the environment. Camille Pissarro (French, 1830–1903), *The River Oise near Pontoise*, 1873. Oil on canvas, 18 1/8 × 21 15/16 in. (46 × 55.7 cm). Clark Art Institute, Williamstown, Massachusetts, 1955.554.

called "civilized society" long excluded colonized people and women, who were relegated to the category of nature.[1] Capitalism has tallied their labor, like the Earth's natural "resources," as all but free, fueling a period of growth as astonishing as it is unsustainable.

Of course, the word *nature*, on its own, needn't summon all these specters of exploitation. It's also convenient: referring to the "more-than-human world" to encompass the animal, vegetable, and mineral can be a bit unwieldy.[2] Still, what is meant by nature is often quite specific, sooner evoking Romantic images of sublime wilderness than less pastoral but still richly biodiverse places, be they swamps or cities.[3] Indeed, the "wilderness" of much nineteenth-century American landscape painting was strategic, portraying land as "pristine" by erasing the presence of Native habitation and thus enabling colonial settlement.[4] In this publication, historian and curator Risa Puleo discusses the aesthetic strategies of settler colonialism, specifically in the context of the Berkshires.

In the late nineteenth century, zoologist Ernst Haeckel coined the term *ecology* to describe "the entire science of the relationship of the organism to its surrounding environment."[5] The word comes from the Greek *oikos*, or home, and shares this root with the discipline of economics, suggesting a related system of exchange among living things. If nature implies something separate from humans, ecology presents a web of life that encompasses all of us. Moreover, if nature suggests an idealized, unchanging construct, then ecology acknowledges actual conditions, differentiated by place, and a history of constant transformation.

This term is not without problems. Like many of his colleagues, Haeckel later endorsed a system of race science and ideas about environment that would reemerge in Nazism. Literary scholar Britt Rusert explains that "the problem of thinking ecology with (or against) race did not really emerge until the first quarter of the twentieth century, when the anthropomorphization of ecological relations began to take shape."[6] As ecology came to inform the social sciences, for example in the Chicago school of sociology, human populations were seen as homeostatic systems subject to external disturbances by "invasive species," often figured as immigrants or people of color.[7] The interdisciplinary field known today as human ecology has developed considerably since then, in scope and self-awareness, and studies topics ranging from public health and urban design to food systems and energy sources.[8] While it

1
Jason W. Moore, ed., *Anthropocene or Capitalocene? Nature, History, and the Crisis of Capitalism* (Oakland: PM Press, 2016), 87. See also Sylvia Wynter, "No Humans Involved: An Open Letter to My Colleagues," *Forum N.H.I.: Knowledge for the 21st Century* 1, no. 1 (Fall 1994): 42–71, and the catalogue of a recent exhibition it inspired: Erin Christovale, ed., *No Humans Involved* (Los Angeles: Hammer Museum, 2021).

2
See David Abram, *The Spell of the Sensuous: Perception and Language in a More-than-Human World* (New York: Vintage, 1997).

3
See William Cronon, "The Trouble with Wilderness: Or, Getting Back to the Wrong Nature," *Environmental History* 1, no. 1 (January 1996): 7–28. On environment as built environment, see Steven Vogel, *Thinking Like a Mall: Environmental Philosophy after the End of Nature* (Cambridge, MA: MIT Press, 2015). On the "nature" of cities, see Fahim Amir, *Being & Swine: The End of Nature (As We Knew It)* (Toronto: Between the Lines, 2020).

4
Alan C. Braddock and Karl Kusserow, introduction to *Nature's Nation: American Art and Environment*, ed. Braddock and Kusserow (Princeton, NJ: Princeton University Art Museum, 2018), 21.

5
Ernst Haeckel, *Generelle Morphologie der Organismen: Allgemeine Grundzüge der organischen Formen-Wissenschaft, mechanisch begründet durch die von Charles Darwin reformierte Descendenz-Theorie*, vol. 2 (Berlin: G. Reimer, 1866), 286; my translation.

6
Britt M. Rusert, "Black Nature: The Question of Race in the Age of Ecology," *Polygraph* 22 (2010): 154.

7
Rusert, 155.

8
Human ecology is a multidisciplinary field that has its own associations, journals, and degree granting programs (see for example the Society for Human Ecology, the journal *Human Ecology*, and programs at College of the Atlantic or Cornell University).

9
See Frederick R. Steiner, *Human Ecology: How Nature and Culture Shape Our World* (Durham, NC: Island Press, 2016).

10
See Giovanni Aloi and Susan McHugh, eds., *Posthumanism in Art and Science: A Reader* (New York: Columbia University Press, 2021); and Cary Wolfe, *What Is Posthumanism?* (Minneapolis: University of Minnesota Press, 2009).

11
My approach is deeply indebted to T. J. Demos's "ecology-as-intersectionality." See T. J. Demos, *Beyond the World's End: Arts of Living at the Crossing* (Durham, NC: Duke University Press, 2020).

12
Kathryn Yusoff, *A Billion Black Anthropocenes or None* (Minneapolis: University of Minnesota Press, 2018), online edition, https://manifold.umn.edu/projects/a-billion-black-anthropocenes-or-none.

13
Christine Howard Sandoval and Jessica L. Horton, "'Genocide Is Climate Change': A Conversation about Colonized California and Indigenous Futurism," *World Art* (March 9, 2023): 1–20. The paper Howard Sandoval references is Alexander Koch et al., "Earth System Impacts of the European Arrival and Great Dying in the Americas after 1492," *Quaternary Science Reviews* 207 (March 1, 2019): 13–36.

may seem redundant to modify "ecology," which considers all species, with the name of one in particular, scholars in that field insist on the outsize significance of humans' reciprocal relationship to their environments.[9]

The exhibition title *Humane Ecology* plays on the name of this discipline by adding an "e" to imply an ethic. It shifts focus from top-down approaches of population-level management to more situated and specific relationships and traditions. It also indulges the redundancy of putting the human back in ecology as a response to recent academic trends toward what is broadly termed "posthumanism"—an acknowledgment that the historical construct of the human is no longer sufficient given our technological dependencies, multispecies entanglements, and disastrous record of anthropocentrism.[10] Well-meaning attempts to decenter the human, however, often miss the point: only certain groups of humans have been central in mainstream environmental thinking.[11] "Humane" is meant as a corrective to these exclusions at a time when environmental discourse routinely prioritizes the interests of the few, shifts responsibility from corporations and governments to individuals, "protects" land by evicting those native to it, or pushes xenophobia as a uniquely "green" position.

Indeed, contemporary discussions of catastrophic climate change may resonate differently for different people. Geographer Kathryn Yusoff writes: "If the Anthropocene proclaims a sudden concern with the exposures of environmental harm to white liberal communities, it does so in the wake of histories in which these harms have been knowingly exported to Black and Brown communities under the rubric of civilization, progress, modernization, and capitalism." Speaking to the apocalyptic alarm felt by many today, Yusoff adds that "imperialism and ongoing (settler) colonialisms have been ending worlds for as long as they have been in existence."[12] In this spirit, artist Christine Howard Sandoval has used the phrase "Genocide is climate change," inverting a more common sentiment, with reference to research that dates the start of the Anthropocene two centuries prior to the Industrial Revolution, when it is often believed to have begun. Geographers have suggested that Europeans' arrival to the Americas in 1492, which led to some 56 million Native deaths over the coming century, shifted land use—and with it, atmospheric CO_2 levels—enough to produce the Little Ice Age, a period that would last some 500 years.[13]

Already in 1970, observing the absence of Black people and their interests from academic and policy discussions of ecology in US cities, sociologist Nathan Hare wrote: "The 'ecology crisis' arose when the white bourgeoisie, who have seemed to regard the presence of Blacks as a kind of pollution, discovered that a sample of what they and their rulers had done to the ghetto would follow them to the suburb." Hare argues that Black Americans "suffer the predicament wherein the colonizer milks dry the resources and labor of the colonized to develop and improve his own habitat while leaving that of the colonized starkly 'underdeveloped.'"[14] Artist and researcher Imani Jacqueline Brown has illustrated these logics in a rural context, showing how Louisiana's former sugarcane plantations, once powered by the labor of enslaved peoples, have been transformed into today's industrial petrochemical plants. This overlay is more than coincidental. Brown writes: "Once industrial monocrop agriculture has drained life from soil, the oil industry spreads throughout the Black Earth's fractal viscera; her skin crawls with prisons and petrochemical plants."[15] For both Hare and Brown, these systems of extraction structure nearly every aspect of American life.

This exhibition's subtitle, *Eight Positions*, reflects the assembled artists' distinct forms of environmental thought and how these are shaped by specific places and ecosystems. The word evokes positionality—that is, how sociopolitical context affects identity, outlook, and agency. Connected to different diasporas, all of the artists in this exhibition live or work in North America. Not all of them are obviously associated with eco art, some of whose early exponents Alena J. Williams discusses in her essay. But all of them think ecologically in both natural and social terms along three main dimensions: relation, representation, and deracination.

RELATION

It is an ecological truism that "everything is connected," but the artists here show the local specificity and character of such connections, some of them ineluctable and others elective. In her formally diverse practice, Carolina Caycedo highlights the labor of care at the center of environmentalism and traces a feminine and feminist lineage of environmental struggle. In tapestries, murals, videos, and artist's books, Caycedo represents farmers, community leaders,

14
Nathan Hare, "Black Ecology," *Black Scholar* 1, no. 6 (April 1970): 3, 8.

15
Imani Jacqueline Brown, "Black Ecologies: An Opening, An Offering," *MARCH* (March 2021): 92.

16
See Carla Acevedo-Yates, "Embodied Spiritual Fieldwork: Dismantling Western Perspectives through Affective Exchanges" in *Carolina Caycedo: From the Bottom of the River*, ed. Acevedo-Yates (Chicago: Museum of Contemporary Art, Chicago, 2020), 24.

17
See Winona LaDuke, "Traditional Ecological Knowledge and Environmental Futures," *Colorado Journal of International Environmental Law and Policy* 5, no. 1 (1994): 128.

18
Merlin Sheldrake, *Entangled Life: How Fungi Make Our Worlds, Change Our Minds & Shape Our Futures* (New York: Random House, 2020), 98.

19
This in contrast to a recent exhibition focused on "symbiotic entanglement." See Caroline A. Jones, Natalie Bell, and Selby Nimrod, eds., *Symbionts: Contemporary Artists and the Biosphere* (Cambridge, MA: MIT Press, 2022).

and Native elders who nurture and protect both human and more-than-human life, often at great risk. What the artist calls "spiritual fieldwork," a personal form of ethnographic research, results in solidarities across place and time that form a common, uninterrupted cause.[16]

Christine Howard Sandoval's recent drawings and sculptures both represent and employ the elemental agency of water and fire and consider their relative balance. Reciprocity and cyclicality are essential tenets of Indigenous ecological knowledge; nothing can be taken without a corresponding offering, and what has come before will come again.[17] Howard Sandoval's soot-on-paper drawings reference both the wildfires and flooding that have ravaged her California homeland in recent years, but also harken back to Native creation myths and long neglected practices of forest management that could help prevent such fires. There is destruction in these works, but also the promise of renewal.

Relations between and within species structure Korakrit Arunanondchai's video *Songs for dying* (2021). The artist's montage connects his aging grandfather with a senescent sea turtle, both destined to return to the ocean before coming back to the world in new form. Here, Buddhist animism meets more recent ecological thought on decentralized networks: in scenes of pro-democracy protestors chanting in the streets of Bangkok and moving as a single mass, a voiceover draws on the writings of mycologist Merlin Sheldrake. Not only are fungi connected by dense underground networks of branching and fusing hyphae, but some species are also more than one: lichens, for example, are made of both algae and fungi, and are known as *holobionts*, from the Greek for "whole." "If we only have words that describe neatly bounded autonomous individuals," Sheldrake writes, "it is easy to think that they actually exist."[18]

REPRESENTATION

Most of the work in this exhibition treats ecological relations in symbolic form, rather than as living things in the gallery, and uses inert media to make images and objects that trouble common perceptions of nature.[19] In Kandis Williams's sculptures, collaged photographs of bare Black bodies in motion, drawn from both dance and pornography, appear to emerge from the leaves of artificial tropical houseplants. Plants, for Williams, are "containers for speculative fiction" and exemplify the way both sentient beings and

cultural forms migrate, adapt, and perform.[20] In Juan Antonio Olivares's *Fermi Paradox III* (2019), a constellation of seashells suspended in the gallery emit samples of found audio. The artist plays on the acoustic association of these objects, and the alien quality of their forms, to concretize disembodied ruminations on humans' cosmic loneliness.

With her outdoor sculptures of alligators curled to suggest the ancient symbol of the ouroboros, the serpent who eats its own tail in a never-ending cycle of destruction and rebirth, Allison Janae Hamilton recodes a symbol of Florida, where she grew up. The alligator is both predator and prey and figures in the racial imaginary of the region as part of anti-Black tropes. By bringing these symbols of the American south to the northern Berkshires, as if they are climate migrants in a warming world, the artist suggests possible lessons from a place she knows intimately. As Britt Rusert has observed, in view of rising temperatures, increasingly frequent natural disasters, and divestment from public institutions and infrastructure, "we are witnessing a veritable Southernization of the globe. Under such circumstances, the history of the South may soon become universal history."[21]

Eddie Rodolfo Aparicio's latex castings of the trunks of trees in the Los Angeles neighborhoods where he grew up capture the minute details of their bark and transfer accretions of pollution and graffiti. There is a twinned history of these trees and the Central American migrants with which they share space, as both were brought to the city around the middle of the last century to perform different kinds of labor and then removed when they were deemed a problem. Beyond image-making, the artist is deeply invested in material histories: latex is a bloodlike sap that heals scarred trees, evoking trauma and repair, and the basis for Indigenous Mesoamerican technologies such as rubber balls and sandal soles, suggesting an alternative lineage of artistic media.

DERACINATION

While ecology concerns the specificity of place—of biomes and microbiomes defined by their environmental conditions—a consistent theme of *Humane Ecology* is uprooting and adaptation. Caycedo traces the medicinal tradition of the Stockbridge-Munsee Band of Mohican Indians, the tribe forcibly removed from the region that includes present-day Williamstown, Massachusetts, and who now reside in Wisconsin. Both Kandis Williams and Eddie

20
Kandis Williams, "In Discussion: Kandis Williams + Amber Esseiva," November 12, 2020, Institute for Contemporary Art, Virginia Commonwealth University, video, 1:16:54, http://icavcu.org/exhibitions/kandis-williams-a-field/#video.

21
Rusert, "Black Nature," 150–51.

Rodolfo Aparicio unpack the parallels between plants and people who have migrated, forcibly or not, to perform labor on the land, and had their cultural traditions appropriated or erased. Janae Hamilton's alligators find themselves in an unexpected environment, harbingers of many more displacements to come. And in Pallavi Sen's garden, which spans the green roof outside the Clark's Lunder Center, the artist chose vegetables of South Asian origin, which are well suited to the rising temperatures and more frequent droughts of the northern Berkshires, well aware of the complexities surrounding the language of "native" and "invasive" species. Sen's project is practical, meant to produce food and seeds, as well as aesthetic and pedagogical, attuning human visitors to the subtle temporalities and collaborative, sculptural dimensions of garden cultivation.

Each of the uprootings evoked by these artists acknowledges the realities of the present, in which globalization, colonialism, and climate change have upset idealist expectations of environmental purity. While the fictions of nature strain to account for these conditions, let alone offer paths for their repair, ecology, with a human lens, can.

EDDIE RODOLFO APARICIO

b. 1990, Los Angeles; lives and works in Los Angeles

Eddie Rodolfo Aparicio grew up with ficus trees, which line the streets of Pico-Union, MacArthur Park, and East Los Angeles. Today, painting latex around their trunks as high as he can reach, the artist makes flattened casts of the trees that capture the grain and scars of their bark and transfer their soot and graffiti—all with an exactitude that makes them look like doubles. Ficus trees were brought to Los Angeles in the mid-twentieth century to shade streets with their wide, fast-growing canopies. They arrived around the same time, and in many of the same places, as migrants who were brought to serve in the labor market through the Bracero Program, a bilateral agreement between the United States and Mexico. Aparicio, whose family is from El Salvador, is struck by these twinned histories, of trees and people who have "lived and grown together." He also notes the unintended consequences in each case: the trees' broad coverage is enabled by buttress roots that break up city sidewalks, causing them to be cut down or removed; Central American guest workers were exploited until they were also deemed a problem, and deported en masse.

Materials matter to Aparicio, who studied painting in graduate school before becoming disenchanted with the way its tools were considered neutral,

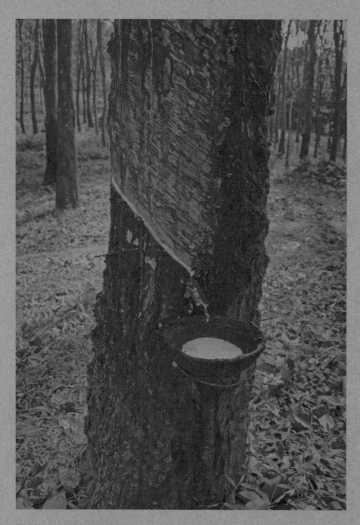

Rubber sap dripping from a tapped rubber tree into a bowl.

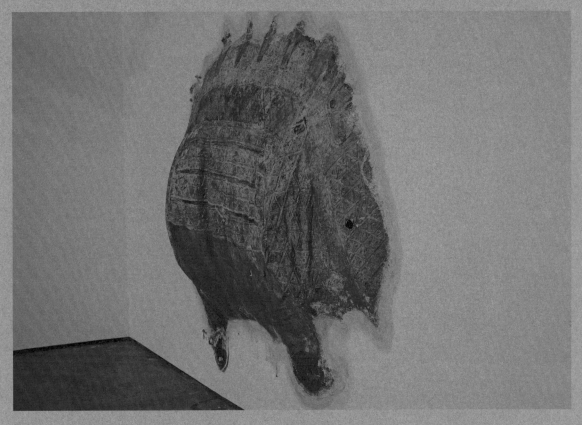

Eddie Rodolfo Aparicio, *Respiro #1 (Alba Petróleo, San Salvador, ES)*, 2014. Rubber, latex paint, sulfur, ammonia, breath, one-way valve, dimensions variable.

despite their extensive European pedigree. Instead, he wanted to find materials with other histories. Back in Los Angeles, Aparicio became interested in rubber as an Indigenous technology, used in ancient Mesoamerica to make soles for sandals and balls for sports. Determined to understand the origins of the material, he covertly visited a plantation in Guatemala where he saw rubber trees carefully sliced to extract their latex lifeblood. While the trees were grown "sustainably," with an eye toward long-term profit, the migrant and Indigenous laborers who cultivated them were treated as disposable, working long hours for little pay as their lungs burned from the ammonia used as an anticoagulant to keep the sap flowing. Closer to home, Aparicio eventually found the same material at a Hollywood special effects store in Burbank, on the other end of the global supply chain.

The tree castings mix media. On one side, Aparcio's curtain-like works tell a material story in which the rubber picks up pollution, graffiti, and organic matter; on the other, images made of cloth and paint are combined into layered compositions that shuttle between El Salvador and Los Angeles in their sampling of visual culture, such as signage and ads. The castings also mix genres: they register impressions like a print, carry painterly gestures, and exist between sculptural relief and textile. They often include three dimensional embellishments: ceramic spikes or shards of green glass appear to grow organically from some and suggest the possibility that the artwork might defend itself. There is softness and

volume, too, as some of the works are stuffed with silk floss from the ceiba, a tree sacred in Mayan culture. The hanging works divide space and present distinct but complementary faces—material and imagistic, natural and cultural—that together form an autobiographical story about what it means to be rooted in place, or between places.

In addition to a hanging work, the installation at the Clark includes a sculptural format unexplored since the artist's time in graduate school, when he made casts of agricultural and industrial equipment used by migrant laborers. In this new work, Aparicio encloses an inflated rubber bladder in a tree casting, which he adheres to the wall with the same latex material. The bulge, which appears animate and somehow symbiotic with the architecture of the gallery, naturally deflates over the course of the exhibition.

Just as the tree castings represent trees using tree matter, this piece uses the artist's own breath as a material in a work about respiration. Aparicio at once invokes the smoggy air breathed by Central American workers in Los Angeles, the ammonia-laced breath of laborers on rubber plantations, and the vaunted air filtration of trees—a kind of work recognized by urban planners today as an "ecosystem service." All of these associations, both material and symbolic, imply webs of interdependence in which the natural and the cultural are inseparable.

—RW

Eddie Rodolfo Aparicio, *El ruido del bosque sin hojas/ The Sound of the Forest without Leaves* (detail), 2020.

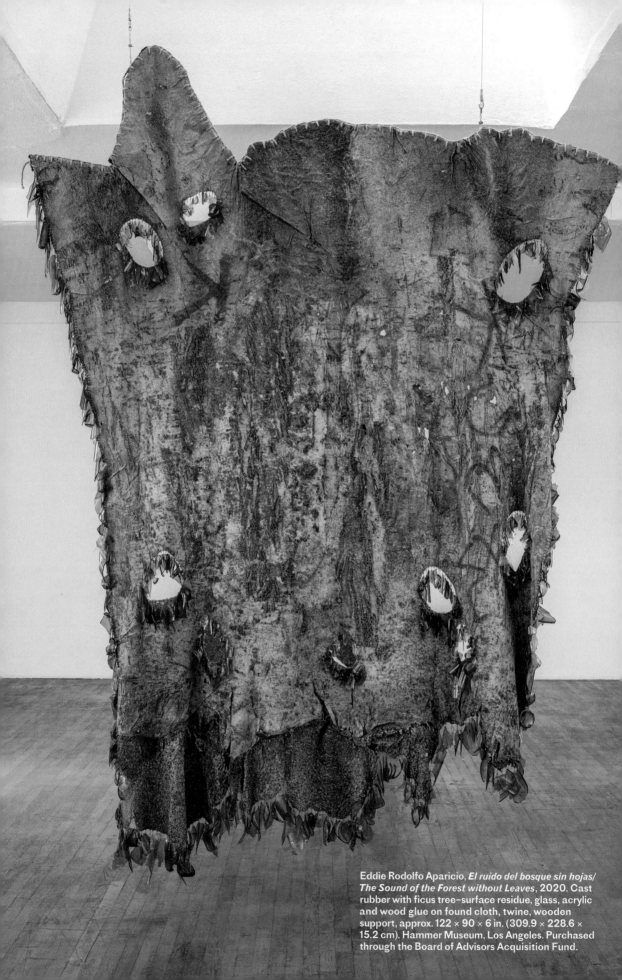

Eddie Rodolfo Aparicio, *El ruido del bosque sin hojas/ The Sound of the Forest without Leaves*, 2020. Cast rubber with ficus tree–surface residue, glass, acrylic and wood glue on found cloth, twine, wooden support, approx. 122 × 90 × 6 in. (309.9 × 228.6 × 15.2 cm). Hammer Museum, Los Angeles. Purchased through the Board of Advisors Acquisition Fund.

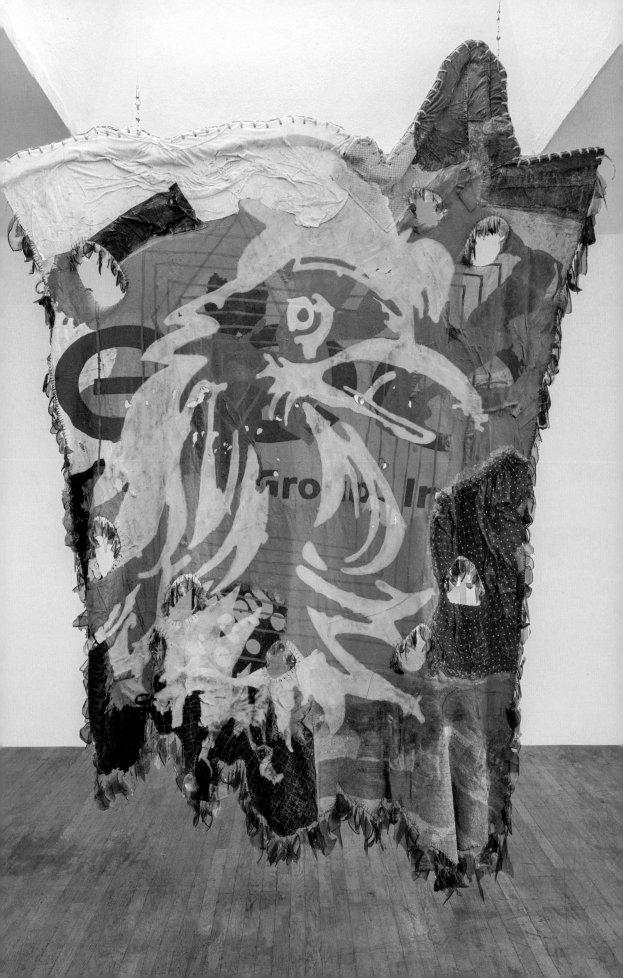

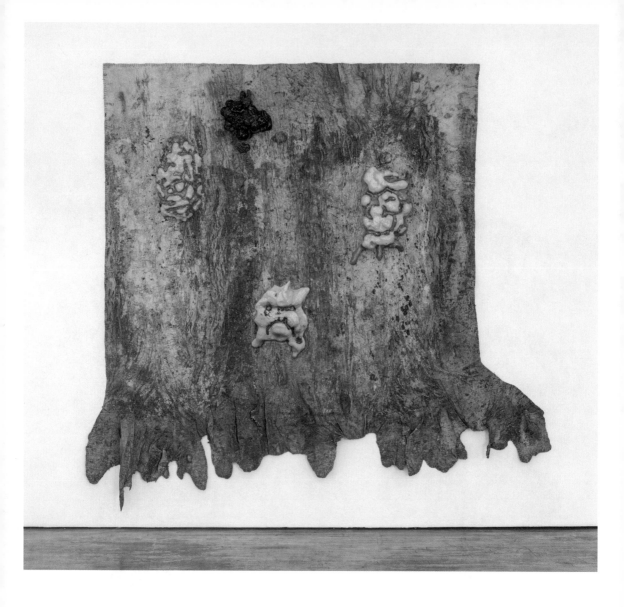

Eddie Rodolfo Aparicio, *Qué pasó con el azufre que botaron?/What Happened with the Sulfur They Dropped?*, 2020. Rubber, glazed stoneware, paint and tree residue, string, clothes, approx. 97 × 106 × 6 in. (246 × 269 × 15 cm).

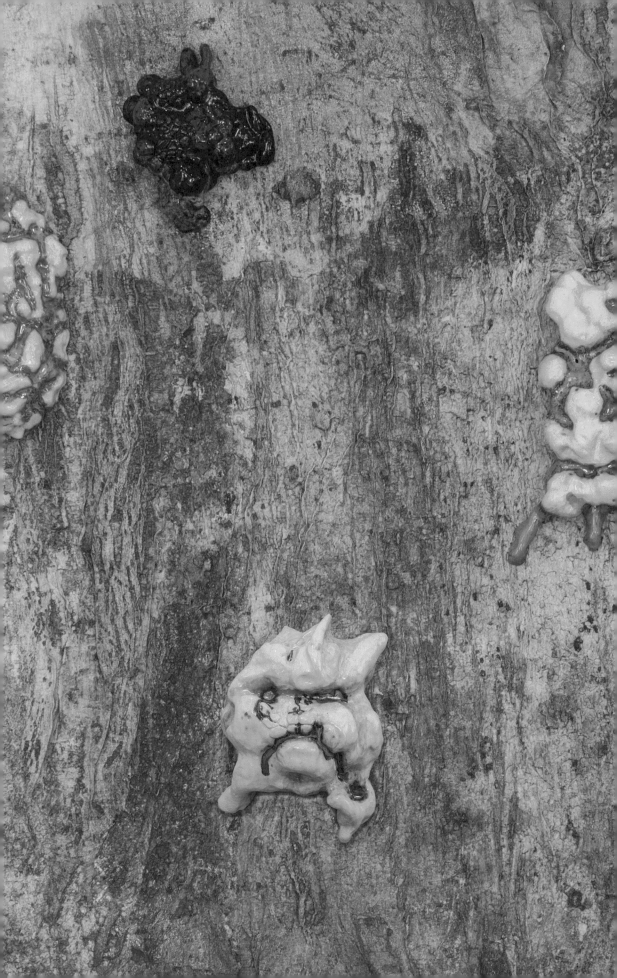

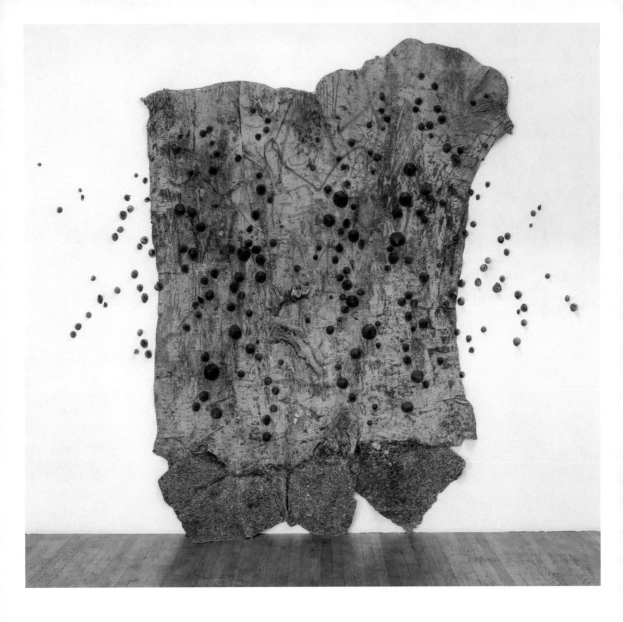

Eddie Rodolfo Aparicio, *La ceiba me salvó/The Ceiba
Saved Me*, 2020. Cast rubber with ficus tree–surface
residue on found cloth, glazed stoneware, twine,
wooden support, approx. 122 × 86 × 5 3/4 in. (309.9 ×
218.4 × 14.6 cm). Collection of Michael Sherman.

27

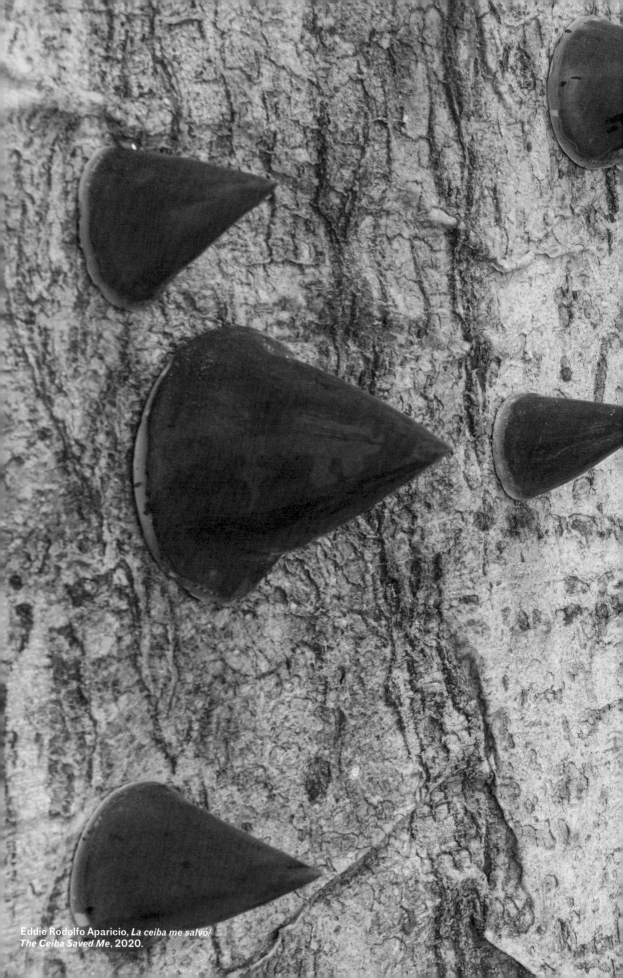

Eddie Rodolfo Aparicio, *La ceiba me salvó/*
The Ceiba Saved Me, 2020.

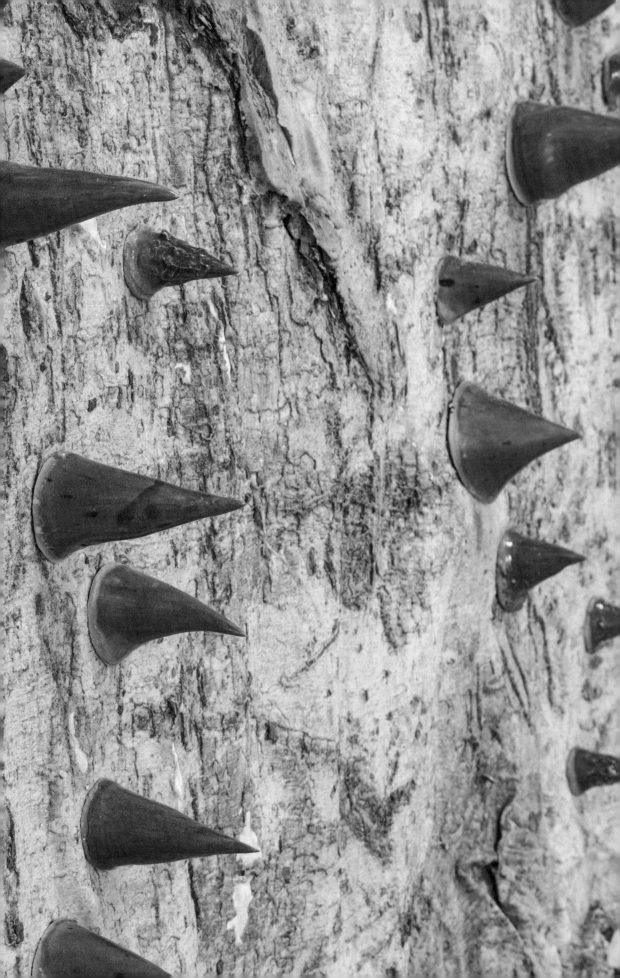

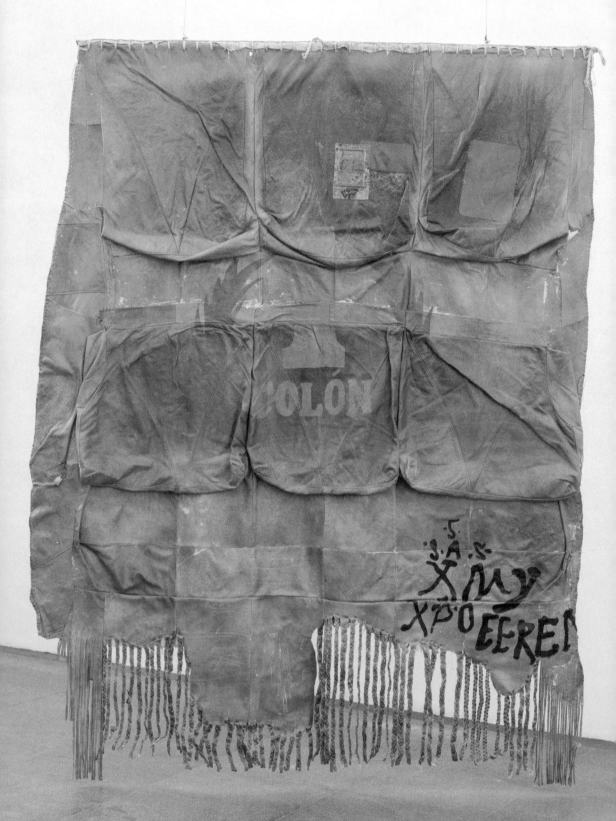

Eddie Rodolfo Aparicio, *De colón a dólar*, 2019.
Cast rubber with ficus tree–surface residue,
acrylic on found leather upholstery, twine, wooden
support, approx. 105 × 81 × 2 in. (266.7 × 205.7 ×
5 cm). Installation view, Páramo, Guadalajara.

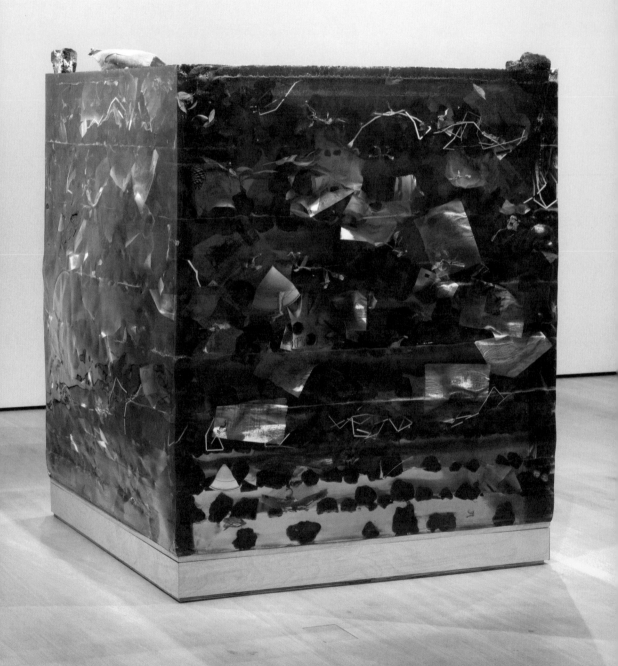

Eddie Rodolfo Aparicio, *Sepultura de semillas*, 2021.
Amber and found objects, dimensions variable.
Installation view, Hammer Museum, Los Angeles.

KORAKRIT ARUNANONDCHAI

b. 1986, Bangkok; lives and works
in New York and Bangkok

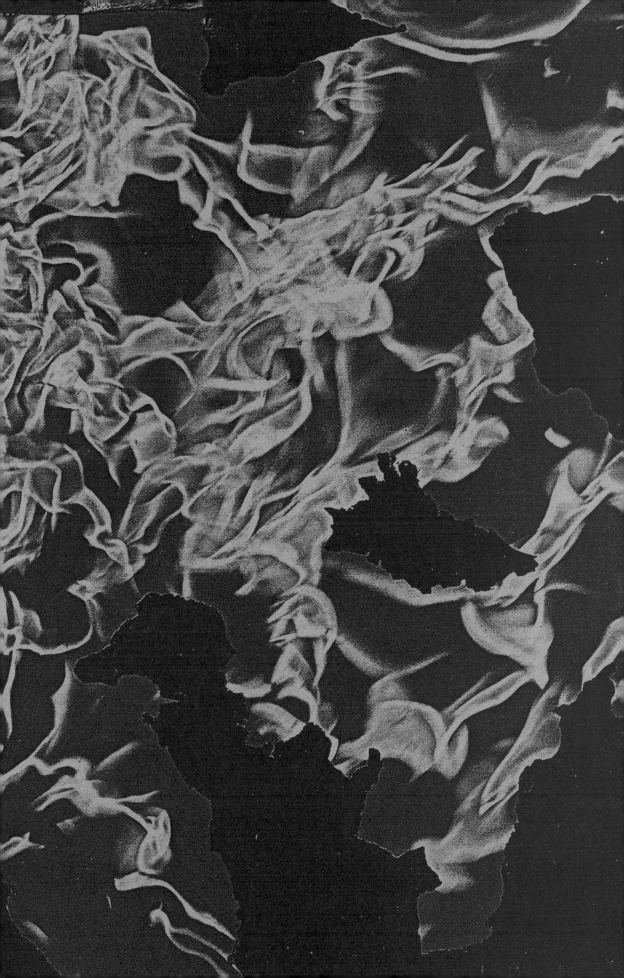

A sea turtle, a shaman, and throngs of chanting protesters are some of the beings connected by touch, memory, and material essence in Korakrit Arunanondchai's video *Songs for dying* (2021). The cyclical structure of the piece is divided into chapter-like passages, or songs, inspired by the artist's grandfather, who raised him and is recorded here transitioning from one life to the next.

The video carries viewers from handheld-camera footage of the artist and his grandfather walking on a beach to dreamlike sequences of a ghostly figure in iridescent robes caressing the cracked skin of a senescent sea turtle. The camera pans patiently, even tenderly, over some scenes, while others pulse to a fast-cutting montage reminiscent of a music video, with a soundtrack to match.

Arunanondchai's title is expressed most directly when he sings to his grandfather on his deathbed to comfort him and awaken memory—that fleeting thing that might also survive the body. The song is Edith Piaf's classic, "La vie en rose," a favorite of the old man in his youth.

"My medium is time, and change," says Arunanondchai. He is also invested in the spiritual medium of the shaman, "an intermediary," in the words of philosopher David Abram, "between the human community and the larger ecological field, ensuring that there is an appropriate flow of nourishment, not just from the landscape to the human inhabitants, but from the human community back to the local earth." We witness such flows in *Songs for dying* as cremated human remains and flower petals are sprinkled over the sea

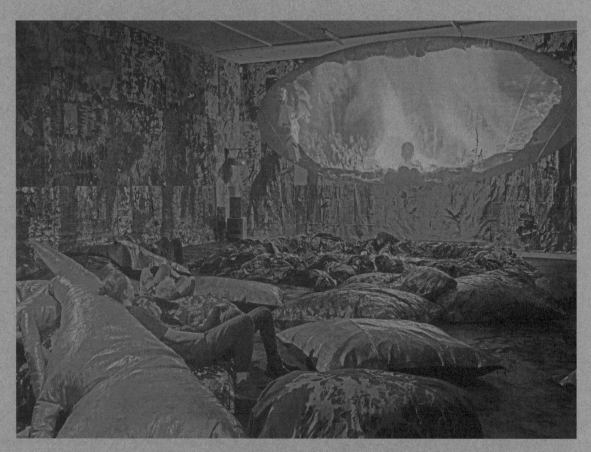

Korakrit Arunanondchai, *From dying to living*, 2022. Installation view, Moderna Museet, Stockholm.

Korakrit Arunanondchai, *The ground begins to breathe*, 2021. Dried funerary flowers, metallic foil, bleached denim, inkjet print on canvas, 82 × 64 in. (208.3 × 162.6 cm).

and animal spirits re-root as saplings. Fire often mediates these transformations and appears regularly in the artist's paintings.

It is shamans, too, who transmit history. *Songs for dying* was commissioned for the 13th Gwangju Biennale in South Korea. Arunanondchai studied the 1948–49 massacre on Jeju Island, when residents opposed to the division of the country following World War II were brutally suppressed and killed by the government, with the support of the US Army, which was governing the island at the time. At least thirty thousand islanders were killed and more than half the villages were burned to the ground. Any mention of the massacre in Korea has, until very recently, been illegal. But local shamans have preserved the story, narrating it in the video from the cosmic level down to the earthly, grisly particulars.

In his video, Arunanondchai takes a similar approach to recent, pro-democracy protests in Thailand. Young people demanding reform of the monarchy link arms and sing, creating a decentralized but intimately bound superorganism described by the narrator using mycological metaphors. Everyone holds their smartphones aloft, with flashlights on, to bear witness, in a scene that the videographer's lens flare transforms into a starry night sky. Like the shamans, Arunanondchai says he "uses the cosmological to address the nature of power. I'm able to communicate how the monarchy and the military have consolidated power in Thailand, for example, in a way that, if I do get to show this video in Thailand, is just about legal." Complex, ambiguous, and otherworldly connections are, for the artist, both an ecologically accurate and a politically strategic way to describe the world.

—RW

follow my voice

Korakrit Arunanondchai, *Songs for dying* (still),
2021. HD single-channel video, color, and sound,
30:18 minutes.

your

reath

Korakrit Arunanondchai, *Songs for dying*
(still), 2021.

Korakrit Arunanondchai, *Songs for dying*
(stills), 2021.

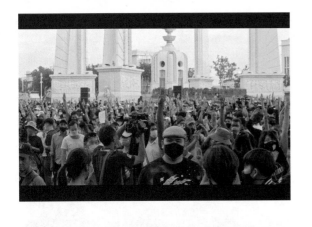

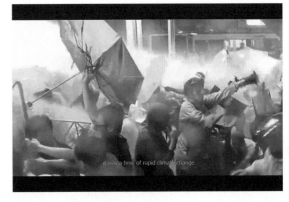

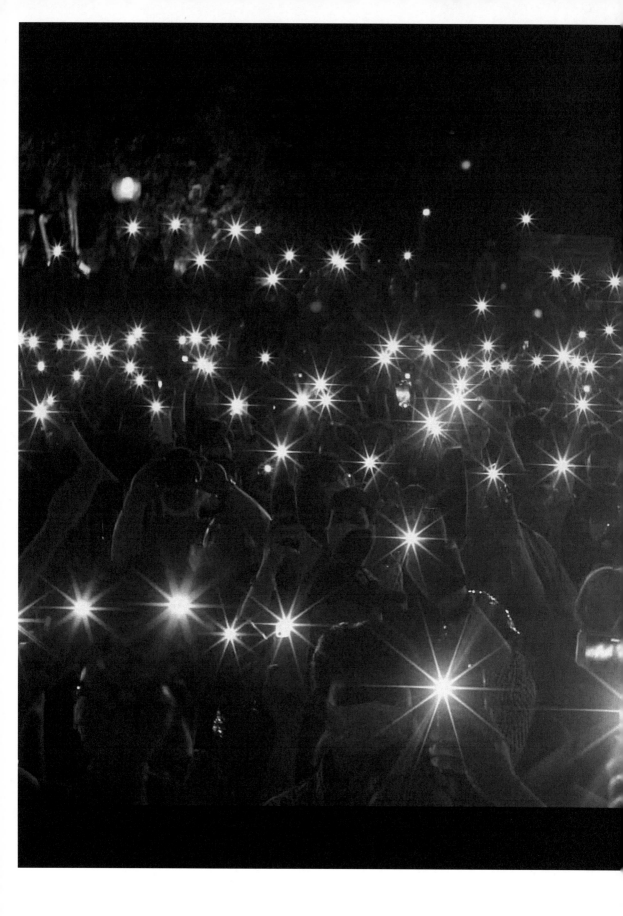

Korakrit Arunanondchai, *Songs for dying*
(still), 2021.

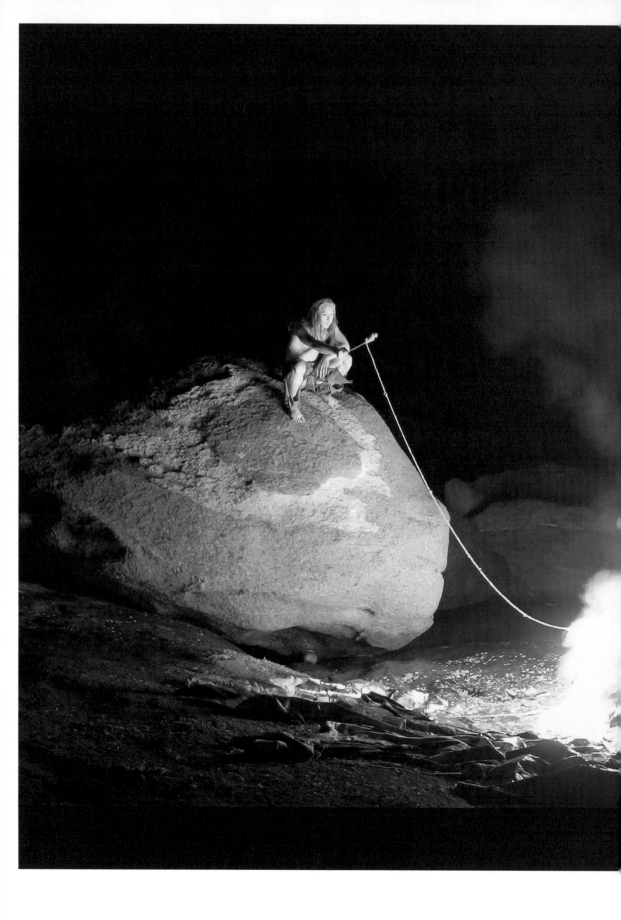

Korakrit Arunanondchai, *Songs for dying*
(still), 2021.

a song for order

Korakrit Arunanondchai, *Songs for dying*
(stills), 2021.

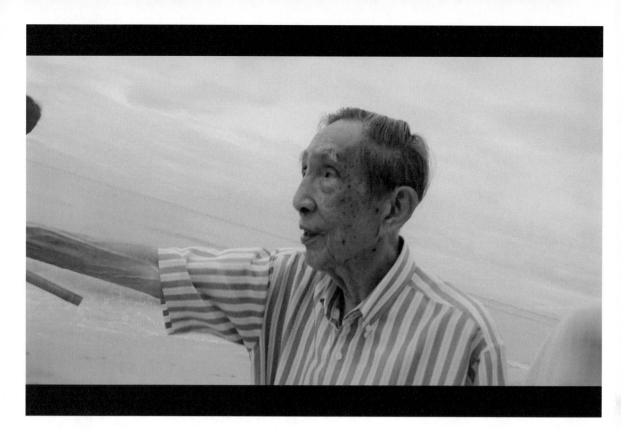

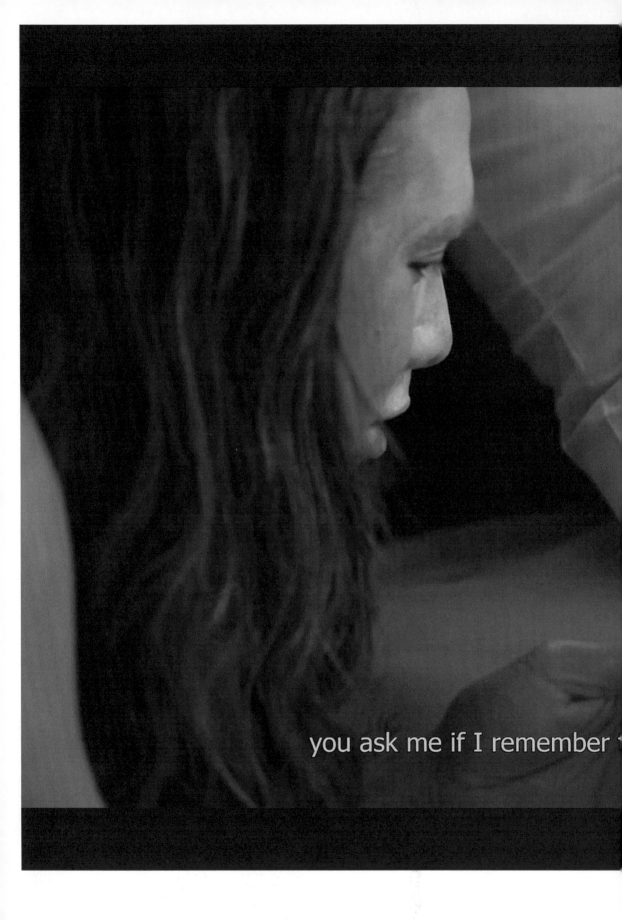

you ask me if I remember

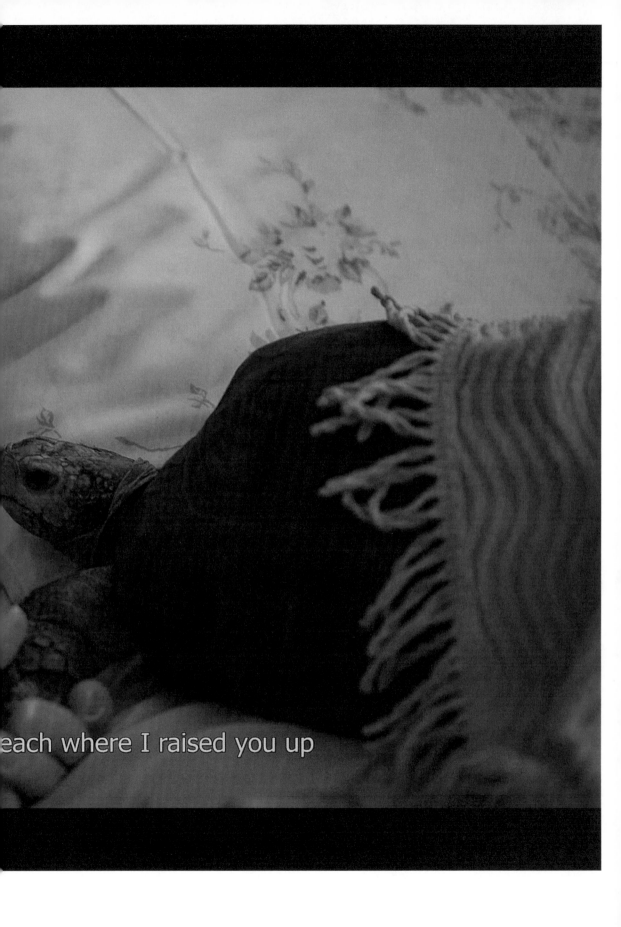

each where I raised you up

Korakrit Arunanondchai, *Songs for dying* (still), 2021.

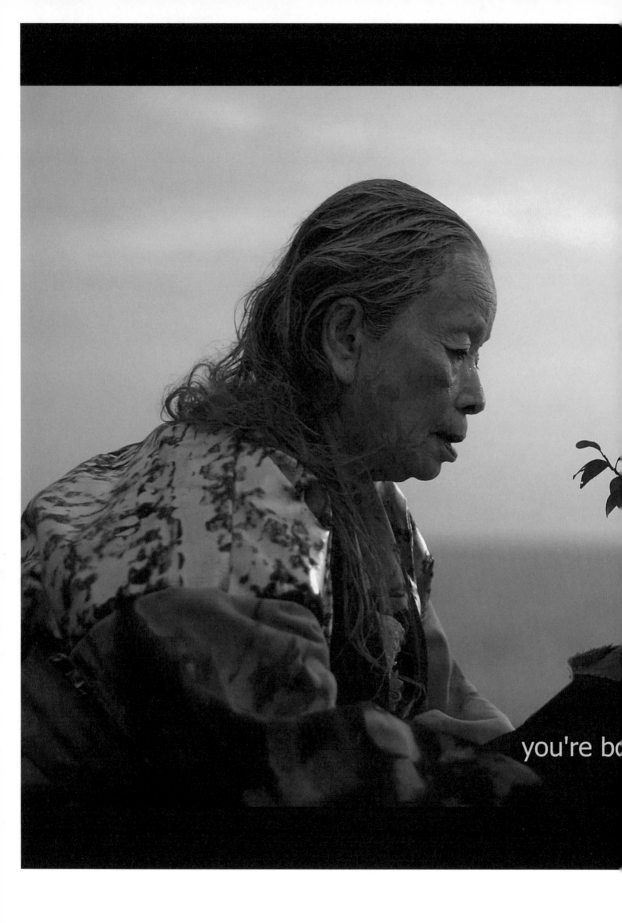

you're b

to a tree

Korakrit Arunanondchai, *Songs for dying*
(still), 2021.

CAROLINA CAYCEDO

b. 1978, London; lives and works in Los Angeles

Carolina Caycedo's installation *Power to Nurture* (2023), which unfolds across a large gallery pavilion at the Clark and its adjoining outdoor space, includes tapestries, murals, and signs that honor the feminine and feminist labor of care at the heart of environmentalism. The artist, who rejects the landscape genre for suggesting a window onto the land, and thus a spurious separation from it, instead prefers portraiture—of both people and plants.

Inside the gallery are a series of banners that combine jacquard woven portraits and text. In one, made in dialogue with the Stockbridge-Munsee Band of Mohican Indians, on whose land the Clark sits (see Risa Puleo's essay in this volume), Caycedo depicts the elder Mohican herbalist Ella Besaw foraging amid a field of wildflowers. This is accompanied by the inscription, "When you take from Mother Earth you can give back by sprinkling tobacco"—Besaw's lesson on the need to make a reciprocal offering to the land from which one takes. This tapestry corresponds to a mural on the gallery wall, painted in collaboration with Williams College students, showing a Native medicine wheel whose four quadrants and colors variously represent cardinal directions, seasons, life stages, or ceremonial plants and the cyclical connections between them. Caycedo has adorned the wheel with representations of a common nettle plant, used in traditional medicine as a tonic during and after pregnancy.

In another tapestry, Caycedo represents Faustina "Tinti" Deyá Díaz (1940–2021), an organizer and environmental defender active in Puerto Rico. Díaz cofounded Casa Pueblo in 1980 in a successful bid to stop a multinational open-pit

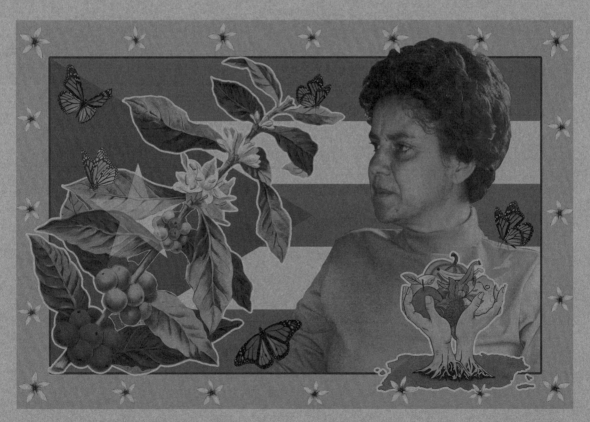

Carolina Caycedo, digital sketch for *Cada sorbo de café será una bendición para ti (Tinti)*, 2023.

Carolina Caycedo, *Care Report* (detail), 2021. Collage.
OXY ARTS, Occidental College, Los Angeles.

mining project. Casa Pueblo continues today as a "community self-management organization" that has built local solar energy capacity, maintains a butterfly reserve, and contributes to the area's economic independence—notably through Café Madra Isla, a sustainable coffee enterprise. "Cada sorbo de café será una bendición para ti" (Every sip of coffee will be a blessing to you) is inscribed beside Díaz's portrait, which is superimposed on a Puerto Rican flag and decorated with coffee plants and monarch butterflies.

Caycedo's visual language borrows from protest culture, with its bold type and bright colors, each with its own significance to the subject represented. The works appear as if they could be picked up and held aloft at any time, as they have been in activations of past installations. Lining the Clark's panoramic windows

and modulating the view to the hills beyond are colorful transparent letters mounted to poles, one per bay, spelling out "Mi cuerpo/Mi territorio" (My body/my land), an ecofeminist slogan declaring possession and sovereignty against the allied forces of patriarchal interference and corporate extraction. Likewise, the freestanding wall outside the pavilion bears a large canvas mural on both sides. On one face it reads "La maternidad será deseada o no será" (Motherhood will be desired, or will not be), a slogan popular within the Marea Verde (green wave) movement that spans Latin America and has seen success in defending abortion rights in majority Catholic countries, as the same rights are disappearing in the United States. Echoing this message is a plant portrait on the reverse side, with yarrow flowers embellishing a stylized

representation of a uterus under the words, "In yarrow we trust." The plant has long been used to end unwanted pregnancies, and in the absence of state protections, Caycedo suggests, one places trust in plants. The artist contends, meanwhile, that attempts to ban such practices—and the use of other plants, whether as recreational drugs or medicines—amount to an unthinkable criminalization of nature itself.

The various parts of Caycedo's installation represent an ongoing assemblage of people, places, and ideas, as well as a transnational network of solidarity and a transhistorical lineage of causes. The artist's research brings her into close contact with the people and places she studies according to a methodology she terms "spiritual fieldwork," in which research is not separated from one's own subjective investment. Caycedo's community continues to expand—always global in scope while connected to the places in which she works.

—RW

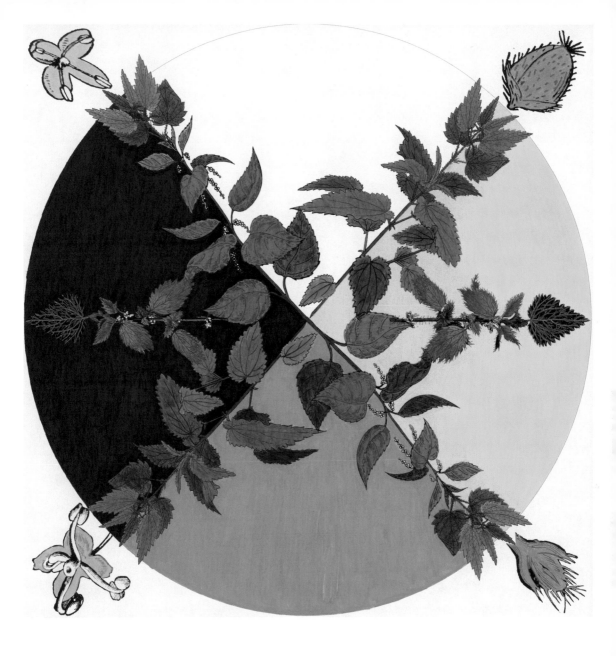

Carolina Caycedo, *Mamma Nettle Wheel*, 2021.
Inkjet print and color pencil on paper, 19 ¹/₂ × 19 ¹/₂ in.
(49.5 × 49.5 cm), edition 1 of 1.

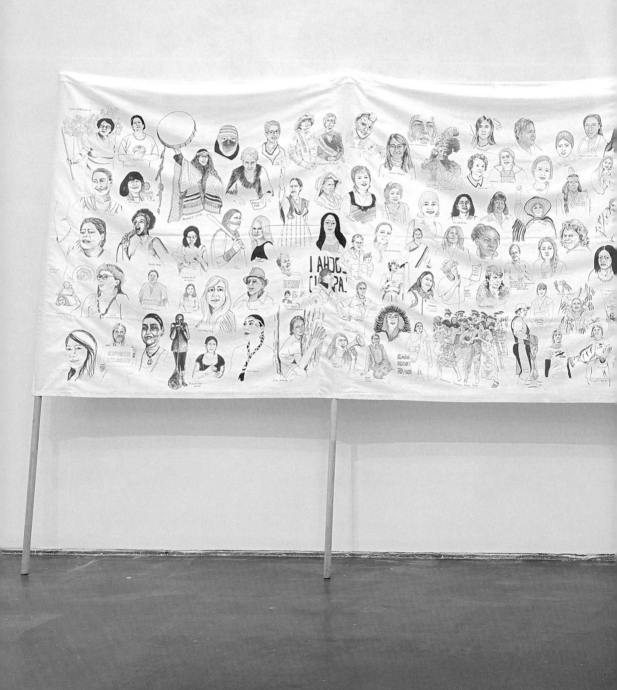

Carolina Caycedo, *From the Bottom of the River*,
2020. Installation view, MCA Chicago.

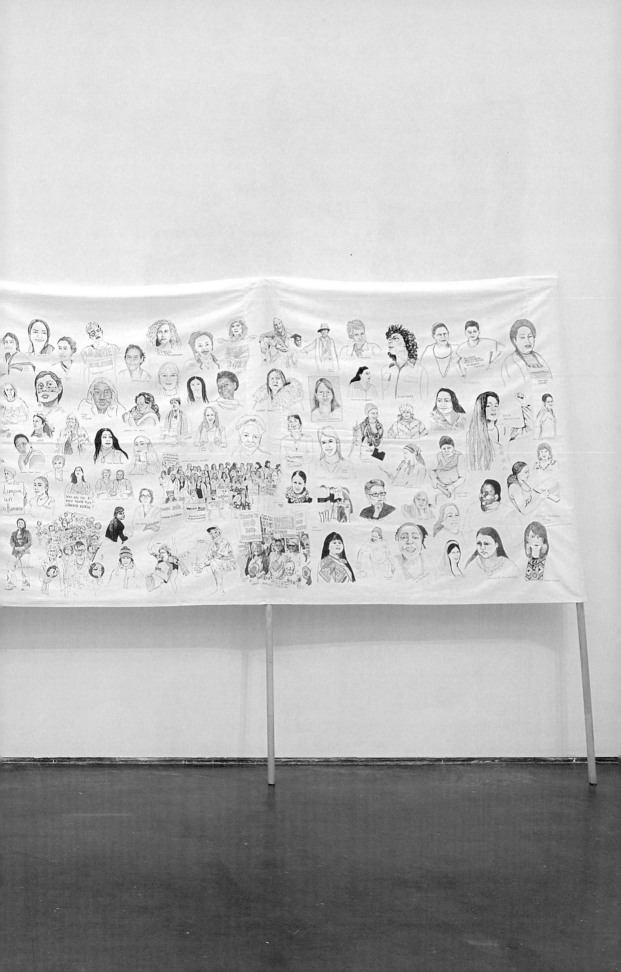

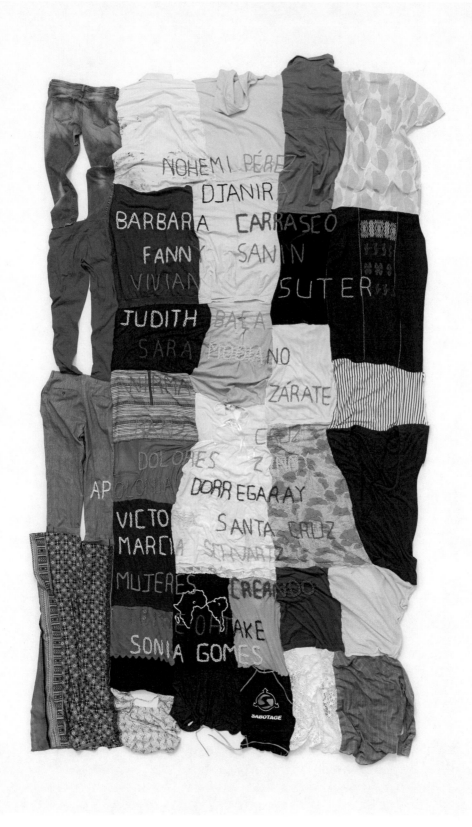

Carolina Caycedo, *Muxeres en mi (Womyn in Me)*,
2019. Embroidery on pieces of clothing, 143 × 71 in.
(365 × 180 cm). Collection El Museo del Barrio,
New York.

NOHEMI PERE

DJANIRA

RBARA A CARRAS

FANN SANIN

IVIAN SU

DITH BAEA

ARA MODIANO

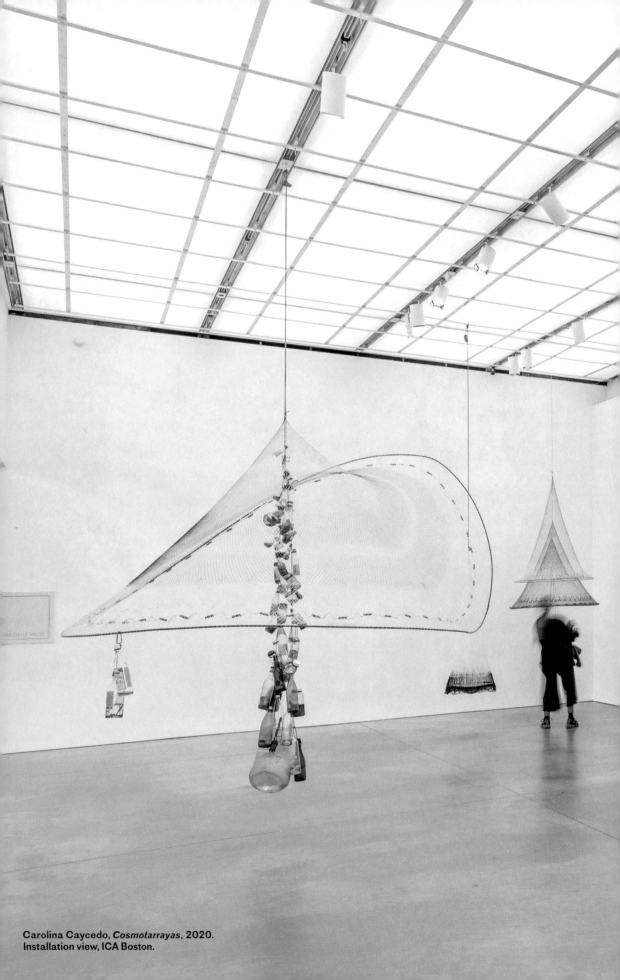

Carolina Caycedo, *Cosmotarrayas*, 2020.
Installation view, ICA Boston.

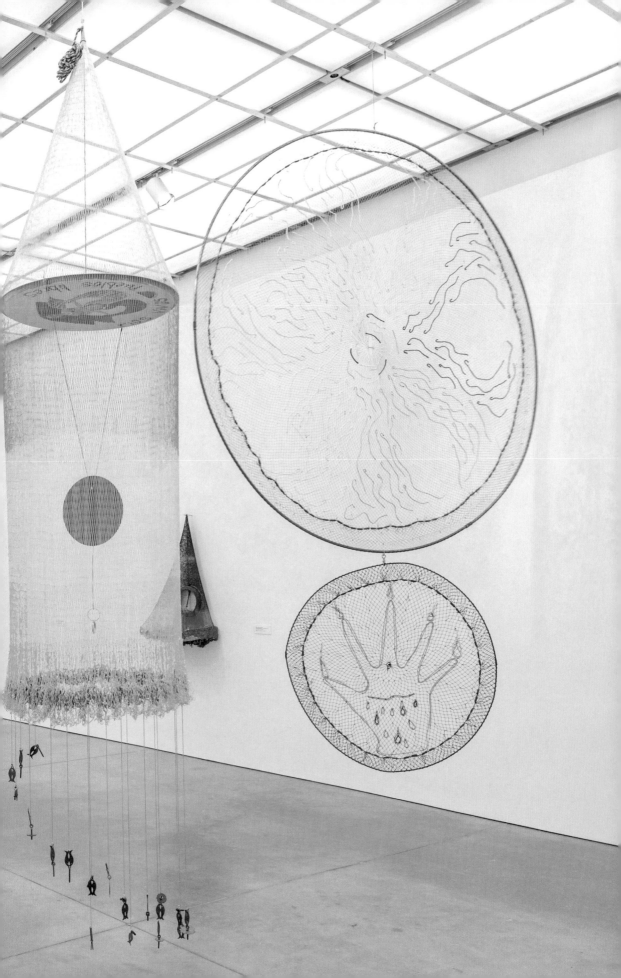

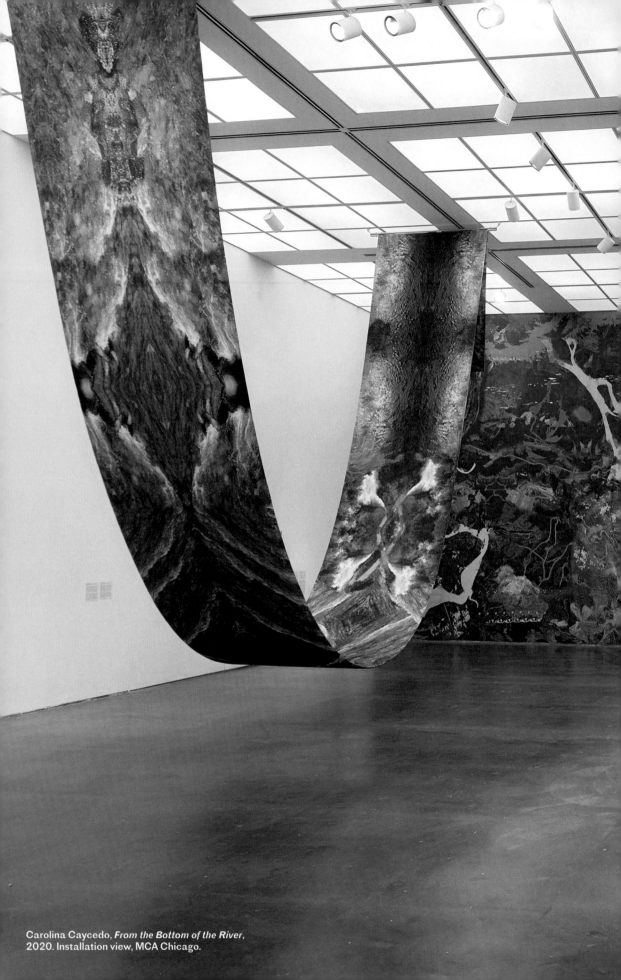

Carolina Caycedo, *From the Bottom of the River*, 2020. Installation view, MCA Chicago.

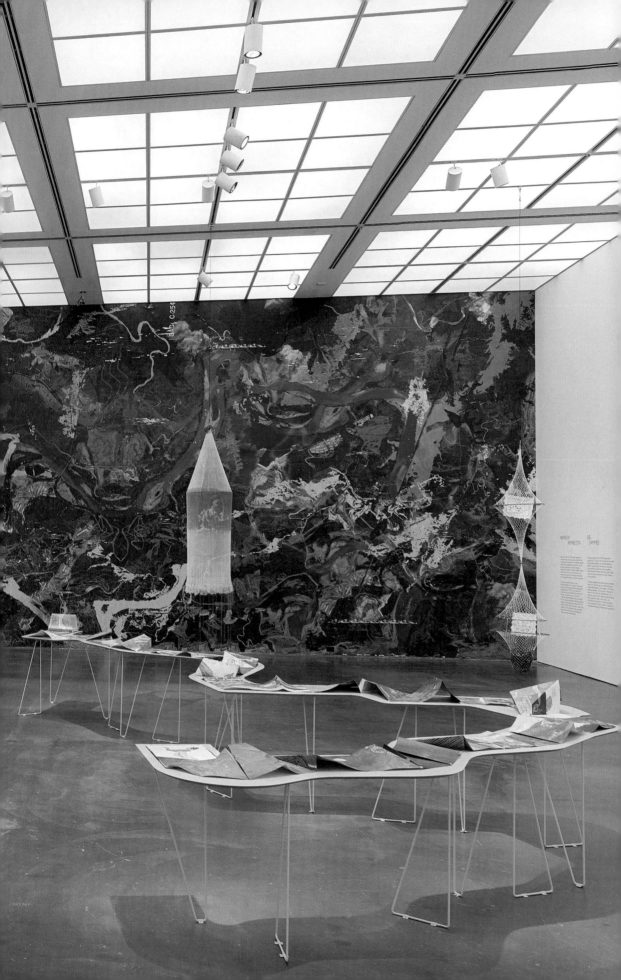

Carolina Caycedo, digital sketch for *When You Take from Mother Earth You Can Give Back by Sprinkling Tobacco (Ella)*, 2023.

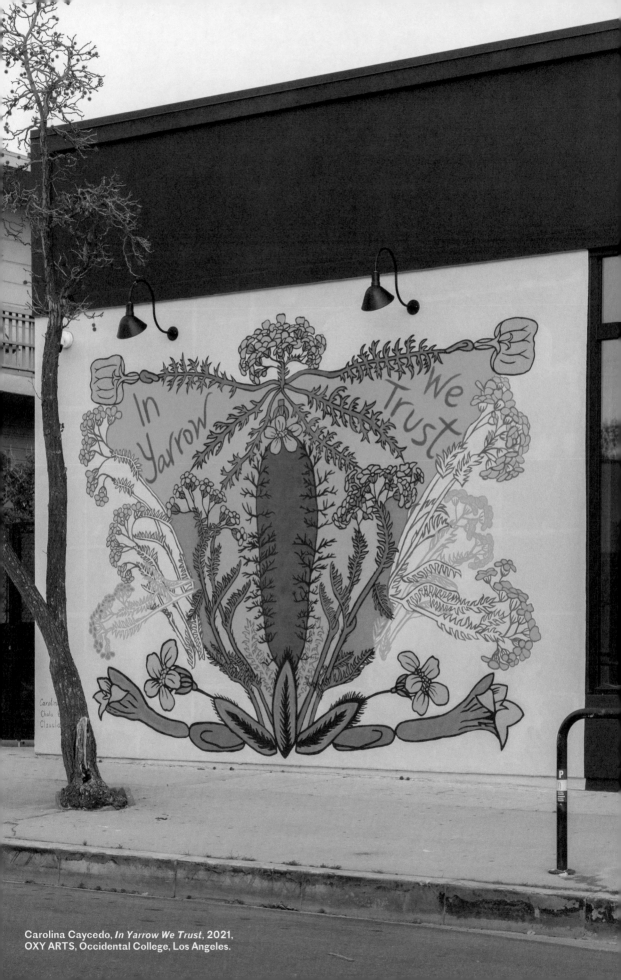

Carolina Caycedo, *In Yarrow We Trust*, 2021,
OXY ARTS, Occidental College, Los Angeles.

DISPOSSESSION AS A WAY OF SEEING: UNFRAMING THE LAND AROUND THE CLARK ART INSTITUTE

Risa Puleo

1
In his history of Williams College, Leverett Wilson Spring writes: "The exact date of the arrival of 'Ephraim Williams, Jun.' at Stockbridge—an Indian Mission where his father settled in 1737—is uncertain, but when he appeared before the justice, he had been in the town long enough to become known as 'the Surveyor.'" Leverett Wilson Spring, *A History of Williams College* (Boston: Houghton Mifflin, 1917), 3–4.

2
Williams's father, Ephraim Williams Sr., was the region's first surveyor and, in 1739, drew the territory's first plans in response to Dutch settlers who were encroaching upon the boundaries of the British colony. Williams Jr. would join him there in 1742.

3
Calvin Durfee, *The History of Williams College* (Boston: A Williams & Company, 1860), 33–34.

4
Different historical sources report different dates for the establishment of the mission, including 1732, 1734, and 1739.

5
Stockbridge-Munsee Community Band of Mohican Indians, "Brief History," https://www.mohican.com/brief-history/.

6
The history of Williamstown from the perspective of the Stockbridge-Munsee can be found in a booklet published in Stockbridge-Munsee Community Band of Mohican Indians, *Stockbridge-Munsee Mohican History in Williamstown* (Bowler, WI: Stockbridge-Munsee Community, 2022).

Three men's visions, across four centuries, transformed the Native land surrounding Williamstown, Massachusetts, into a colonial landscape mediated by images. The terms that Ephraim Williams Jr. established for Williams College, Thomas Cole for landscape painting, and Sterling Clark for the Clark Art Institute continue to frame the land in the region and make dispossession appear to be part of a natural order.

SETTLING THE WILDERNESS,
CONVERTING THE WILD

In his time, Ephraim Williams Jr. was known as "the Surveyor," a moniker that pointed to his profession: he divided and mapped undeveloped land into plots that could be sold as private property.[1] The Williams family was one of four designated by the provincial government of the Massachusetts Bay Colony to fortify English territory west of Boston by establishing settlements and supporting Reverend John Sergeant's Protestant mission at Stockbridge.[2] Named after a town in England that British settlers thought the Berkshires resembled, Stockbridge, Massachusetts, is thirty-five miles south of where Williamstown would be established fifty years later.[3] The mission had been established in 1732 to consolidate Mohican peoples into one area after disease, famine, and war diminished their numbers and reduced their ancestral domain.[4] As "the people of the waters that are never still," Mohicans took their name from the Mahicannituck River, now called the Hudson, around which their territory spanned from Lake Champlain to Manhattan. Mohicans were also given a new name by settlers after being forcibly move to Stockbridge, in the first of many displacements. Together with the "Wappingers, the Niantics, Brothertons, Tunxis, Pequot, Mohawk, Narragansetts, and Oneida" peoples drawn to the mission, Mohicans would come to be known generally as "Stockbridge Indians."[5] In addition to proselytizing this assembled group, William Jr.'s father, Williams Sr., also sold them goods on credit with land as collateral, knowing there was little chance that he would be paid back.[6] Missionary work was an opportunity to gain the trust of Native people with the intention of appropriating their land. Williams Sr. accumulated enough land to be able to consolidate it into an estate that he bequeathed to his son, who would use it to continue his father's charge of establishing settlements and converting Native people.

Today, Williams Jr. is best known for actions manifested after his death in 1755: his will states that his accumulated properties be used to establish a town and a school.[7] But an earlier will articulates Williams's original design for Williams College as an educational center dedicated to "promoting and propagating Christian knowledge amongst the Indians at New Stockbridge," continuing his father's and Sergeant's mission.[8] By the time that Williamstown was established in 1765 and Williams College in 1793, missionaries and other settlers near Stockbridge used methods similar to Williams Sr.'s to appropriate most of the mission land into private property, forcing the Stockbridge Indians to the forested outskirts of the town. By 1786, in their second displacement, most Stockbridge Indians had been relocated to Oneida lands in New York, to a town that they would call New Stockbridge; Williamstown would come to be inhabited primarily by settlers.

Despite the presence of Native inhabitants, in the eyes of these two surveyors, obscured by the lens of their profession and their own culture, the Americas appeared to be primed for taking under the Right of Discovery. In *Ceremonies of Possession in Europe's Conquest of the New World, 1492–1640*, Patricia Seed describes how the seemingly ordinary tasks of making maps, building houses, constructing fences, and planting gardens are central to British modes of colonial claim staking.[9] Though it may seem obvious that new occupants in a region would need to build themselves a place to live and plant food to eat, the day-to-day business of occupation in colonial New England should not be taken for granted. Houses and fences signaled ownership. Without obvious signifiers of ownership, the entirety of the Americas appeared to the British settlers to be unowned and unused. Such assumptions are based on a Protestant moralization of work. As landscape architect Joan Iverson Nassauer writes in "Messy Ecosystems, Orderly Frames," colonial British penchants for mown lawns, tidy perimeter fences, and trim rows of plants reflects a taste for neatness—a value integrally tied to labor, or its lack, on the land. Nassauer calls this cultural preference the "look of care" because it is an aesthetic that shows how much labor has been instilled to cultivate and maintain the land.[10] Nassauer essentially describes how the British philosopher John Locke's labor theory of property—which states that land becomes property when mixed with the "labor of [man's] body and the work of his hands"—has become an aesthetic preference and a policeable standard.[11]

7
To read the entirety of Ephraim Williams Jr.'s 1755 will, consult Calvin Durfee, *The History of Williams College* (Boston: A. Williams & Company, 1860), 405–10.

8
Ephraim William Jr.'s 1748 will can be found online: "Ephraim Williams Jr. early will," Ephraim Williams Project, Williams College Digital Collection, https://librarysearch.williams.edu/discovery/delivery/01WIL_INST:01WIL_SPECIAL/12288469860002786.

9
See Patricia Seed, *Ceremonies of Possession in European Conquest of the New World, 1492–1640* (Cambridge: Cambridge University Press, 1995).

10
Joan Iverson Nassauer, "Messy Ecosystems, Orderly Frames," *Landscape Journal* 14, no. 2 (September 1995): 163, 165.

11
John Locke, "Of Property," *Second Treatise of Government; and a Letter Concerning Toleration* (1689; Oxford: Oxford University Press, 2016), 14–15. Locke continues: "Though the Earth, and all inferior Creatures be common to all Men, yet every Man has a *Property* in his own *Person*. This no Body has any Right to but himself. The *Labour* of his Body, and the *Work* of his Hands, we may say, are properly his. Whatsoever then he removes out of the State that Nature hath provided, and left it in, he hath mixed his *Labour* with, and joyned to it something that is his own, and thereby makes it his *Property*. It being by him removed from the common state Nature placed it in, hath by this *labour* something annexed to it, that excludes the common right of other Men. For this *Labour* being the unquestionable Property of the Labourer, no man but he can have a right to what that is once joyned to, at least where there is enough, and as good left in common for others."

12
In *Wild Things: The Disorder of Desire*, the queer theorist Jack Halberstam points out the multiple meanings of the term "wild" from the Oxford English Dictionary in the epigraphs of the first three chapters. The first meaning is a general qualifier that describes a state of growth or development "without restraint or discipline." The second meaning describes land: "1. *Wild*—(of a place or region) Uncultivated or uninhabited; hence, waste, desert, desolate." The third meaning describes people. "2. *Wild*—(of persons) Resisting control or restraint, unruly, restive; flighty, thoughtless; reckless, careless; *fig.* not according to rule, irregular; erratic; unsteady." Jack Halberstam, *Wild Things: The Disorder of Desire* (Durham, NC: Duke University Press, 2020), 3, 33, 51.

13
Richard Hakluyt, "Discourse of Western Planting" (1584), http://nationalhumanitiescenter.org/pds/amerbegin/exploration/text5/hakluyt.pdf.

14
While claim making was continuous throughout the British colonies, the process differed from colony to colony. In New England, a map preceded the claim. See Roger J. P. Kain and Elizabeth Baigent, *The Cadastral Map in Service to the State: A History of Property Mapping* (Chicago: University of Chicago Press), 285–86.

Without the active trace of labor, the wilderness, and even untended, settler-owned properties, were primed to be interpreted as in disrepair, and could be actively acquired by those able to labor in ways other settlers would recognize as work.

If early colonial settlers could see the wilderness only as unproductive and unmaintained, through these same terms they would see the people ancestrally descended from the land only as idle, wild—"savage."[12] The mission at Stockbridge subjected Native people to Christianity, the cultural image that colonists designed for them. The British politician and propagandist Richard Hakluyt employed gardening metaphors to describe the colonial project as the intentional cultivation of both the wilderness and the wild in his 1584 "Discourse on Planting." In this impassioned plea to Queen Elizabeth to earn support for settlement, Hakluyt described the pilgrimage of Christians to the Americas as "planting one or two colonies of our nation upon that firm [land]." Once there, converting Native people was viewed as a task of implanting "the sweet and lively lines of the gospel" into Native minds that had been "purged" of Indigenous culture.[13] Settlement and conversion, then, were how the Williams family aimed to bring order to both the wilderness and the wild. As the son of a missionary, Williams Jr.'s task was to convert Native people in service of a purpose determined by a Christian God. As the Surveyor, it was his task to divide the wild from the cultivable and further subdivide land into legible plots of property available for purchase for future settlements.

The tasks of settlement and conversion are intricately tied to the idea of "improvement." Simply put, to improve is to make better. Within the burgeoning arena of capitalism that coincided with British colonial settlement in the Americas, to make better was to make productive. Whether by developing land into a town or converting a Native population through Christian education, the idea of improvement implicit in the tasks of settlement and conversion were fundamental to British concepts of empire and to distinctly British processes of colonization. The models of improvement implemented in the mountain plain between the Hoosac and Hudson Rivers functioned through many mechanisms.[14] Here, I focus on two of these mechanisms to bring forth the ideologies of improvement, settlement and conversion, and wilderness and civilization from the 1750s of Ephraim Williams Jr. into Thomas Cole's 1830s paintings and Sterling Clark's 1955 museum. Map making and house building not only shaped

the land of New England into a landscape but also had a profound effect on the art that would come to picture that landscape.

EPHRAIM WILLIAMS JR.'S
TAKING OF VIEWS

In Ephraim Williams Jr.'s New England, a surveyor mapped adjacent plots of land so that colonists could settle in townships. The tools used to survey land were developed for military purposes, and Williams Jr.'s line of work would benefit him during his military service in two of the four French and Indian Wars.[15] Both surveying and surveillance required high vantage points from which to see a vast territory at once. From this position, maps could be drawn up and encroaching enemies could be identified in advance of their arrival. In war times, these maps would be used to strategize battle plans; in peacetime, to develop settlements that could fortify a claimed territory and fend off future wars. After his service, Williams Jr. encouraged the soldiers who had been stationed around Fort Massachusetts to settle there. A town bearing his name self-commemorates Williams Jr.'s efforts to settle and reinforce the colonial presence in the region.

Within the military context from which it developed, the practice of mapping and sketching a territory from an aerial position was historically called the "taking of views." While the term is meant to be understood idiomatically to mean the creation of a schematized picture from a site with a view from above, its phrasing should not be underestimated: in battle, whoever controls the visual field most often controls the territories, and ultimately, takes it through conquest. While a map is a tool that helps an army take control of a territory, in the context of British surveying and settlement practices, a map was also the mechanism by which land was taken and distributed into the hands of individual occupiers as property. Beyond these two forms of literal taking, to take a view is to also impose an ideology upon the land. The imposition of a British colonial ideology upon the Americas transformed the land into a landscape.

The geographer Denis Cosgrove defines "landscape as a way of seeing in a European visual tradition."[16] By this, Cosgrove means that to map or draw a place is a practice of laying Western rules of perspective over land, but also over and above other(s') ways of engaging with that land. The transformation of land into landscape, in Cosgrove's words, "achieved visually and

15
As Seed explains, each country involved in the land grab for the New World had its own culturally specific land-claiming methods—what she calls rituals because of their ceremonial aspects—that were unrecognizable to other colonialists. When different claim-making techniques came into conflict, the result was often war. The French and Indian Wars are an example of such conflict, leading both the French and British empires to assume rights upon the land. Remember, too, that Williams Sr. moved his family west to fortify British settlements from Dutch colonists nearing too close to British territory. Seed, *Ceremonies of Possession*, 1–12.

16
Cosgrove specifically names "Euclidean geometry as the guarantor of certainty in spatial conception, organization, and representation." Denis Cosgrove, "Prospect, Perspective and the Evolution of the Landscape Idea," *Transactions of the Institute of British Geographers* 10, no. 1 (1985): 47.

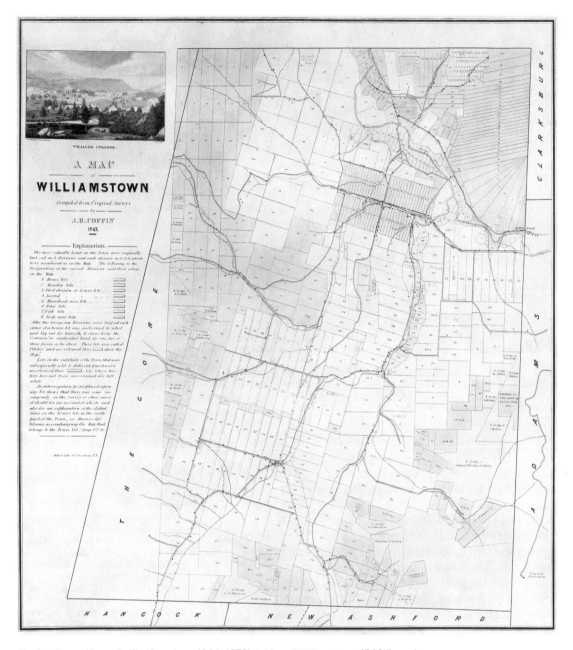

Fig. 1 James Henry Coffin (American, 1806–1873), *A Map of Williamstown*, 1843 (based on information from 1750). Courtesy of Boston Rare Maps, Southampton, Massachusetts. James Henry Coffin held a number of teaching positions, including one at Williams College from 1840 to 1846. During this time, he created the first map of the early settlement of Williamstown, showing how land was partitioned into categories that were allocated equitably among the settlers of the previous century. Coffin used the detailed written information recorded in the town's *Proprietors Book* from 1750. The map shows how land was distributed to these settlers according to the medieval European open-field system. House parcels were clustered together along Main Street. Using a lottery system to ensure fairness, each proprietor was allocated a series of portions containing good farming land, lesser farming land, freshwater marshes, and various woodlands.

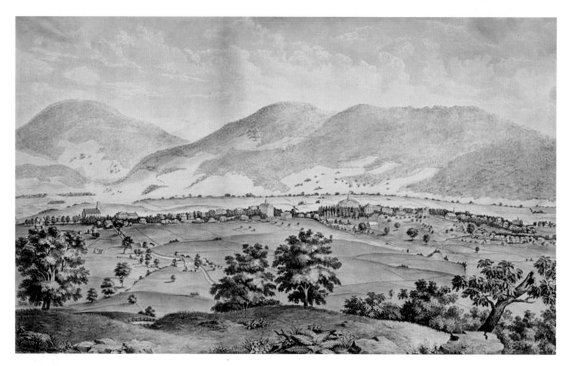

Fig. 2 George Yeomans (American, 1833–1895), *Williamstown, MA, as Seen from Stone Hill*, 1855–56. Hand-colored lithograph, printed by P. S. Duval Co, Philadelphia, PA, 15 3/8 × 26 in. (39.1 × 66 cm). Miriam and Ira D. Wallach Division of Art, Prints, and Photographs, Print Collection, New York Public Library.

ideologically what survey, map making, and ordinance charting achieved practically: the control and domination over space as an absolute, objective entity, its transformation into the property of individual or state."[17] In New England, Williams Jr. helped shift an embodied, on-the-ground engagement with land, in which the Native people understood themselves to be one part of an interconnected ecosystem, into a view from above that placed humans—more specifically, British men— at the top of a hierarchy. Creating a distinction between man and the natural world entrenched the assumed supremacy of a white heteropatriarchy and transformed the land into an manipulatable landscape image.[18]

A comparison of two images of Williamstown shows that to see landscape is also to see property. A cadastral map (a map that defines the boundaries of land ownership) from 1750 is similar to the type of maps that Williams Jr. would have drawn up as a surveyor (fig. 1). Together with George Yeomans's lithographic portrait of Williamstown from 1855–56 (fig. 2), the two images picture the evolution from map to landscape painting filtered through military, colonial-cartographic, and

17
Cosgrove, 46.

18
Cosgrove describes landscape as "a composition and structuring of the world so that it may be appropriated by a detached, individual spectator to whom an illusion of order and control is offered through the composition of space according to the certainties of geometry." He continues: "Landscape distances us from the world in critical ways, defining a particular relationship with nature and those who appear in nature, and offers us the illusion of a world in which we may participate subjectively by entering the picture frame along the perspectival axis." Cosgrove, 55. The distanced and detached view from above creates a space where land is beheld as an object separate from and distinct from its occupant. Moreover, the vantage point used for the practical purposes of surveying and surveillance would be elevated into the ideal view point for considering art, as championed by aesthetic theorists like Immanuel Kant.

artistic realms. Both images were made from the perspective of Stone Hill—the highest point nearest to Williams College, just behind what is today the Clark Art Institute. This vantage point is implied in the cadastral map, which would have established the properties available for settlement and, after purchase, be used for taxation. Map viewers look down onto the lines that divided the valley into individual tracts of land. The same vantage point is imposed in Yeomans's *Williamstown, MA, as Seen from Stone Hill*. The schematized two-dimensional map presents an illusion of three-dimensional space. Some of those individual plots are inscribed into the land as fenced-off edges of fields and farmland. Other tracts have been filled in by houses and buildings. Both images describe the same space in different styles and at different stages in its development, but for similar purposes. By employing the same high vantage point, Yeomans completes the world that the cadastral map sketches out, and in so doing valorizes and participates in an aestheticization of land as property and the naturalization of property as landscape. *Property* is a way of seeing.

THOMAS COLE'S
CONVERSION OF LAND
The techniques gained from military surveillance to survey land became the foundational methods for making landscape paintings, a pursuit that further codified the transformation of physical land into a landscape image. Based in the Catskill Mountains, Thomas Cole also painted in the Berkshires, as glorified in his 1836 painting *View from Mount Holyoke, Northampton, Massachusetts, after a Thunderstorm—The Oxbow* (fig. 3). Made concurrently with debates about Manifest Destiny and the United States' intent to settle and convert the west, *Oxbow* employs light to convert the land to a Christian landscape image. The sun, outside of the frame of the image, illuminates the cultivated, neatly plotted fields in the right half of the painting, which is meant to correspond to the already-settled east. On the left half of the painting, a cloud-darkened sky casts in shadow an undeveloped wilderness at the top of the mountain. Signifying the newly incorporated west, this wilderness is shown by Cole to be subject to the will of God: a lightning-struck tree demonstrates how natural elements aid in clearing the land and prime it for development. In Cole's vision of the landscape, conversion is no longer a task addressed to people; the land, itself, is now Christian.

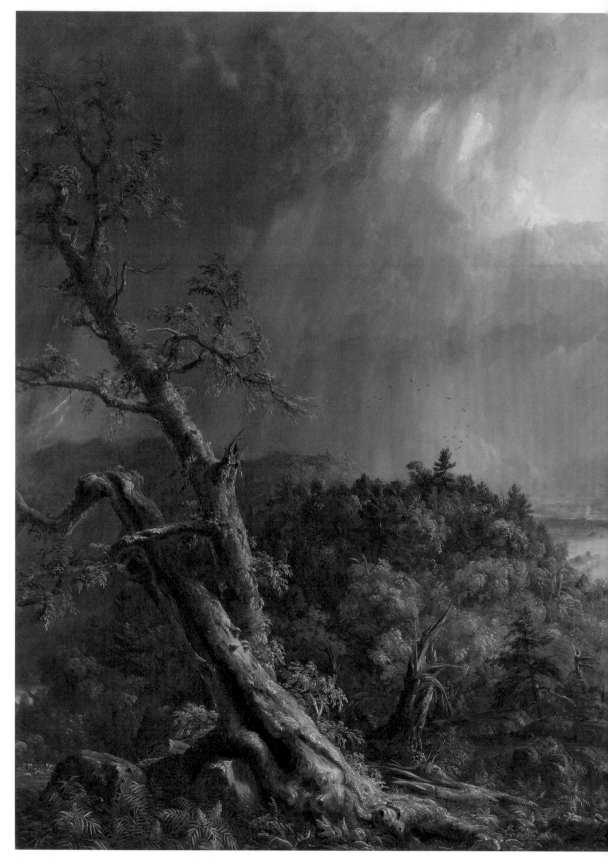

Fig. 3 Thomas Cole (American, 1801–1848), *View from Mount Holyoke, Northampton, Massachusetts, after a Thunderstorm—The Oxbow*, 1836. Oil on canvas, 51 1/2 × 76 in. (130.8 × 193 cm). Metropolitan Museum of Art, gift of Mrs. Russell Sage, 1908, 08.228.

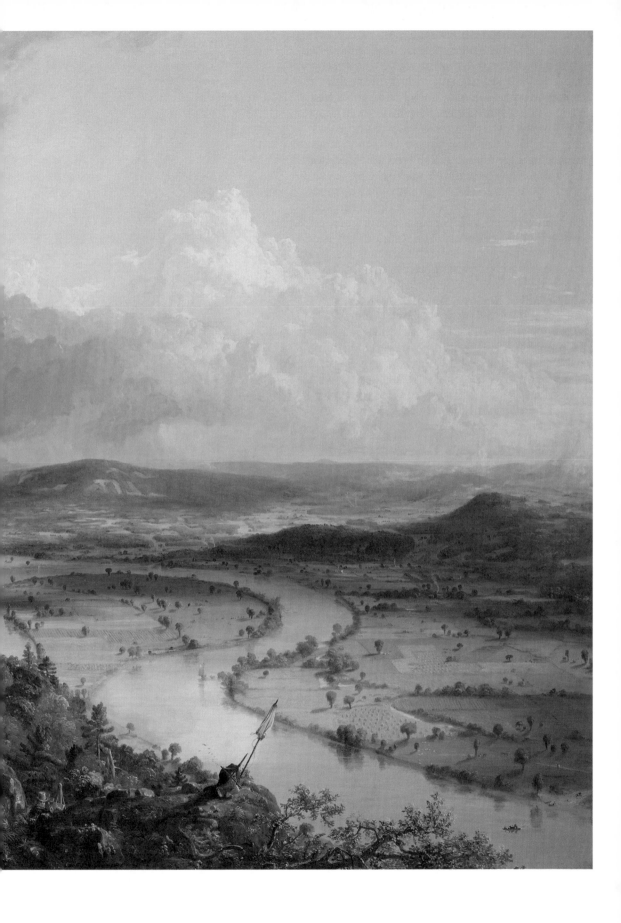

Cole visualized the entanglement of surveying, surveillance, and landscape painting, demonstrating how the artist took on the role of the surveyor. The artist painted himself in miniature at the apex of Mount Holyoke, above the oxbow bend in the Connecticut River, fifty miles southeast of Williamstown. While his palette and easel reinforce his status as a painter, the same vantage point would have been taken by a soldier scanning the range for enemies and by a surveyor dividing the land below into individual properties. Standing at the edge of the light, the artist has replaced the surveyor as the vanguard of cultivating the wilderness. Through the eyes of the painter-surveyor-soldier, the land is idealized in a sweeping vision that equates the landscape with a soon-to-be-settled nation.

The Indian Removal Act of 1830 made it possible to imagine a converted Christian nation. A campaign promise of President Andrew Jackson, the act forcibly removed all Native tribes living in the eastern half of the country to west of the Mississippi. This national regulation followed an earlier initiative in New York: attempts of Mohican and other Native peoples to lease their land to white settlers quickly tumbled into a wholesale loss of all of their properties by 1825. In their third displacement, the Stockbridge Indians living on Oneida land, and the Oneida themselves, were moved to Wisconsin. They called their new home, on the edge of Lake Winnebago, Stockbridge. Others made their way to Indiana, only to find that the land they arrived at had similarly been sold to white settlers, forcing them to turn toward Wisconsin. They were joined by 100 people from the Munsee Delaware tribe, becoming the Stockbridge-Munsee. Some, anticipating that the Indian Removal Act, which was put into action in 1832, pushed further west, moving directly to Kansas and Oklahoma.

Today, the Hudson River School Art Trail, a project of the Thomas Cole National Historic Site, invites viewers to reconnect nineteenth-century American landscape paintings to the sites from which they were painted through specially designed hikes (fig. 4). Their slogan: "Step into a landscape painting."[19] The strategic vantage points used to gain military control over a territory have become the scenic viewpoints that often predetermine our contemporary desires of the land. The experience of the land is framed by an experience of landscape painting and aspirations to optically dominate the land inherited from settler colonialism.

19
Thomas Cole National Historic Site, "Things to See and Do," https://thomascole.org/things-to-see-and-do/.

Dispossession as a Way of Seeing

20
Seed, *Ceremonies of Possession*, 18.

21
Within the context of the metropole, fences—those constructed of wood and stone or planted as hedges—had accumulated significance as markers of private property for centuries before the British set foot in the Americas. Beginning as early as the twelfth century, the commons, that is, lands open to use by all, began to be claimed and cordoned off with fences into individual plots of owned land. By the fourteenth century, privatization was the new standard for land use, shifting the economic and social structure of the country from feudalism to capitalism. The enclosure movement was well underway when the first colonists landed at Plymouth and Jamestown, and thus, the earliest laws in the new colonies required that "every man shall enclose his ground with sufficient fences or else to plant." Seed, 16n30.

STERLING CLARK'S CIVILIZING PROJECT

Once land had been identified as available to claim, the next step in the British colonization process was to frame that land with a fence or build a house upon it. According to Seed, "To build a house in the New World was for an Englishman a clear and unmistakable sign of an intent to remain—perhaps for a millennium. Houses also establish a legal right to the land upon which they were constructed. Erecting a fixed (not movable) dwelling place upon which a territory, under English law created a virtually unassailable right to own the place."[20] Where a house transformed the land beneath it into property through its use as a habitation, a fence delimited the expanse of that property.[21] A fenced property unaccompanied by a house communicated an intent to use the bounded land as a field for planting, that is, a plantation. Fences announced ownership, made an owner's intentions visible, and defined the extent of their responsibility. As settlers took on a new identity after gaining independence—no longer British colonial subjects but now US Americans—they translated the logic of improvement through habitation or plantation into guidelines for future settlements. For instance, the Homestead Act of 1862 allowed US citizens to claim 160 acres of land from territories established as reserved for Native

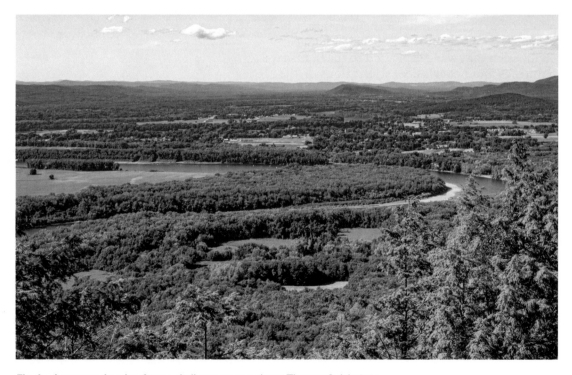

Fig. 4 A present-day view from a similar vantage point to Thomas Cole's *Oxbow*, just south of Northampton, Massachusetts.

people by the Indian Removal Act thirty years earlier, provided that they improve upon it in some way.[22] The logic of settlement followed the United States' territorial border as it moved west. Colonization—one settler, one house, one fence at a time. As Cosgrove reminds us, "That illusion [of control and domination over the land] very frequently complimented a very real power and control over fields and farms on the part of patrons and owners of landscape paintings."[23]

In the Berkshires, 190 years passed between when Williamstown was established and when Sterling Clark built a museum to present his collection of paintings. The exterior of the Sterling and Francine Clark Art Institute was designed by architect Daniel Perry in 1955, with great input from Clark himself, to resemble a house for the gods—Greco-Roman gods—with its white marble temple and columned portico topped with a pediment (fig. 5). The interior galleries, conversely, are scaled to the proportions of a grand manor to encourage an intimacy of viewing the paintings similar to when they adorned the walls of the couple's home. Likewise, windows that punctuate the building's facade emphasize the domestic. Moreover, the windows allow visitors to consider the 140 acres of land surrounding the Clark in relation to the painted images of landscape inside.

The Clark Art Institute's interiors were designed to resemble a residence, and even included a private apartment within the museum (for the Clarks to stay in while in Williamstown). Beyond the potential to literally inhabit the museum, Clark also sought to occupy a very specific image of civilization that was deeply tied to the landscape paintings and neoclassical stylizations of the previous century. A series of landscape paintings by Cole help to unpack the ideology-driven image of civilization that Clark aimed to inhabit. Again, Cole, a British-born artist who set the terms for American landscape painting throughout the nineteenth century, demonstrates how property as a way of cultivating civilization permeates US American cultural beliefs well beyond the moment of their colonial importation.

Cole's *The Course of Empire* (1833–36) is a series of five paintings; each presents a different allegory via landscape. Together, they place the American landscape into a linear path of progress that "illuminate," in Cole's words, "the History of a natural scene, as well as be an Epitome of Man—showing the natural changes of Landscape & those effected by man in his progress from Barbarism to Civilization, to Luxury, the Vicious state or

22
The last of the Indian Intercourse Acts that established the boundaries of Indian Territory was signed in 1834, but the Mexican American War of 1848 (which ceded control of what would become the states of California, Arizona, New Mexico, Colorado, and Nevada from Mexico to the United States) and the California Gold Rush of 1849, meant that white settlers would pass through Indian Territory on their ways to California and Oregon, leading to the erosion of reserved land.

23
Cosgrove, "Prospect, Perspective and the Evolution of the Landscape Idea," 55.

Dispossession as a Way of Seeing

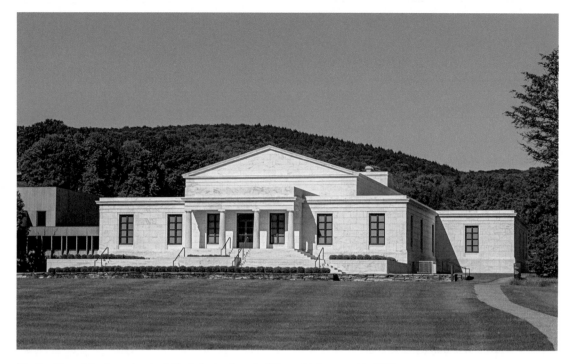

Fig. 5 The original neoclassical Clark Art Institute building, which opened in 1955.

24
Thomas Cole to Luman Reed,
September 18, 1833, quoted in
Ella M. Foshay, *Mr. Luman Reed's
Picture Gallery: A Pioneer
Collection of American Art* (New
York: Harry N. Abrams, 1990), 130.

25
John Wannuaucon Quinney,
"Fourth of July Address at Reids-
ville, New York" (1854), History
Is a Weapon, http://www.
historyisaweapon.com/defcon1/
johnquinney1854fourthofjuly
address.html.

state of destruction and to the state of Ruin &
Desolation. The philosophy of my subject is drawn
from the history of the past, wherein we see how
nations have risen from the Savage state to that of
Power & Glory & then fallen & become extinct."[24]
Mohican diplomat John Wannuaucon Quinney
addressed the colonial intention to extinguish
Native life in his 1854 speech to Fourth of July
celebrants in Reidsville, New York—a municipality
southeast of Albany on Mohican land—when he
spoke: "Indifference of purpose and vacillation
of policy is hurrying to extinction whole commu-
nities [of Native people]."[25] Quinney's speech was
made in advance of the Dawes Act of 1887, which
forced the transfer of reservation land into indi-
vidually owned properties to further dismantle
Native protections. As many individuals could
not afford to take ownership, their land was sold
to settlers who would break up the continuity
of tribal lands as well as the assembled unity of
Native people. The continued insistence of seeing
land as property worked first to cleave people
from the land and, then, people from each other.

Like *Oxbow*, the first painting in *The Course
of Empire*, *The Savage State* (c. 1834; fig. 6), fea-
tures an overgrown wilderness at sunset under
the looming threat of a storm cloud—a sign of

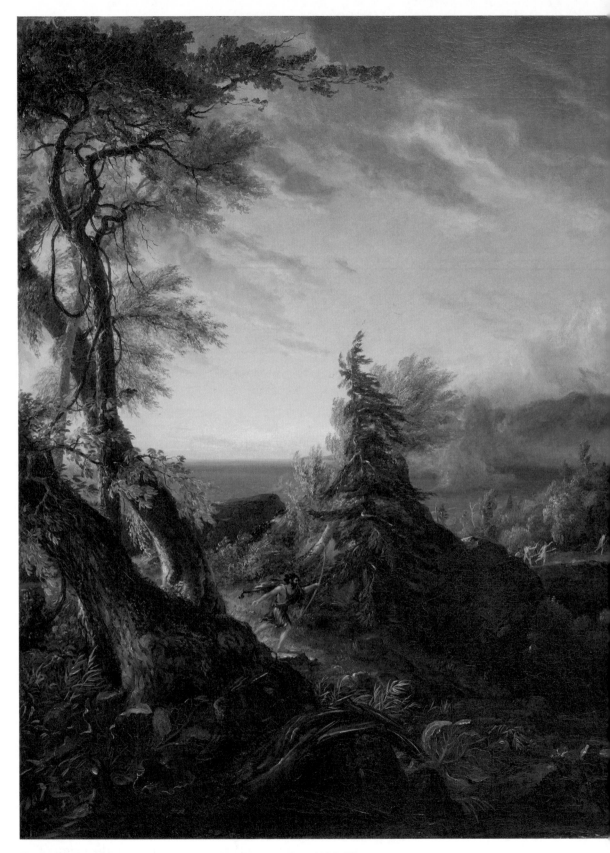

Fig. 6 Thomas Cole, *The Course of Empire: The Savage State*, c. 1834. Oil on canvas, 39 1/4 × 63 1/4 in. (99.7 × 160.7 cm). New York Historical Society, gift of the New York Gallery of the Fine Arts.

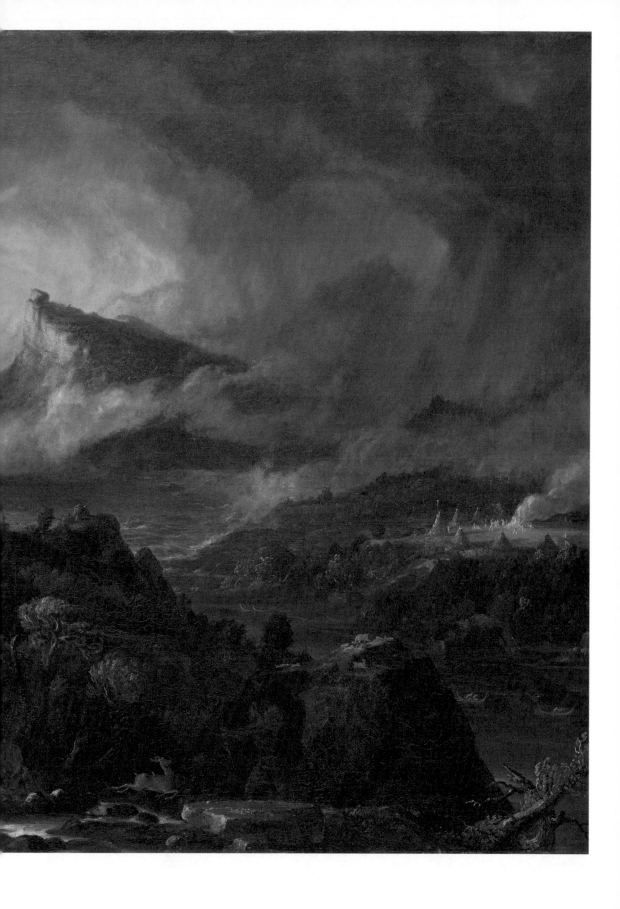

God's displeasure consistent with Cole's Christian nationalist symbolism. Where in *Oxbow*, Native peoples have been omitted from the scene, here, they are shown engaged in a precolonial state roughly 250 years out of date with the lives of the Stockbridge-Munsee living in Wisconsin. Additionally, Cole's image of Native people is out of place with his New England references; the teepee pictured is an Indigenous architecture of the Plains. Portrayed in a ritual dance, Cole's image of Native people perpetuates the association established by Richard Hakluyt in 1585.

The second painting, *The Arcadian or Pastoral State* (1834; fig. 7), stakes a claim for the United States as an inheritor of a Grecian utopian ideal. Arcadia is a region in Greece that has become synonymous with a harmonious balance between humans and nature, an idea that Cole transposes onto an American landscape. This balance is demonstrated by the ways in which Cole has relegated trees and other unwieldy plants to the edges of open fields. There, they frame a small Greek temple and mown lawns that give humans an equal presence in the landscape. Plants provide services, like shade to humans, in contrast to *The Pastoral State*, which depicts Native peoples as subordinated to nature.[26] Native people are absent in the second image in Cole's series, implying the extinction of barbarism that the artist wrote about as a precursor

26
In the moment in which the Clark was built, development and industry had clear cut the mountains of their trees. The current landscape that surrounds the museum is the result of the ecological restoration of subsequent generations.

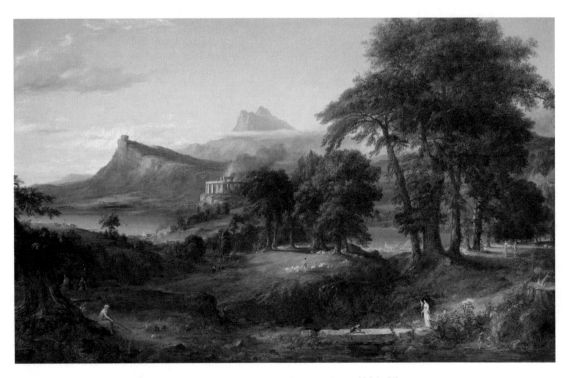

Fig. 7 Thomas Cole, *The Course of Empire: The Arcadian or Pastoral State*, 1834. Oil on canvas, 39 1/4 × 63 1/4 in. (99.7 × 160.7 cm). New York Historical Society, gift of the New York Gallery of the Fine Arts.

Fig. 8 A south-facing view of the Clark Art Institute campus and landscape, 2019.

to civilization. Again, Cole uses sunlight as a demonstration of God's approval of the changes made to the land. A new day has, literally, dawned in the second painting. Through Cole's imagery, the dawn signals the beginning of civilization and equates it with the era of colonialism.

Landscape as a painting genre and neoclassicism as an architectural style emerged concurrently after France and the United States gained independence. The resurgence of classical tenets materialized twice historically: first during the Renaissance, when ancient Greece and Rome were idealized, and later, after the revolutions, when they were viewed as bastions of democratic society that the newly free nations sought to emulate—hence, the design of US government buildings and institutions in a neoclassical style. As claims of the land shifted from monarchs to independent citizens, landscape painting would come to be the primary mode of art making in the newly formed United States, merging notions of patria (homeland) with the singularity of property ownership. In choosing to replicate an enduring image of Greece and Rome, Clark established his museum as an inheritor of these notions in a new era. Clark further inscribed permanence and endurance into his museum when he carved the following words into the building's

foundations: "Within these walls is to be housed beauty which has already stood the test of time and which will far outlast the tumult of today. In this place men and women will be strengthened and ennobled by their contact with the beauty of the ages."[27] In style and purpose, the Clark Art Institute embodies Seed's reading of houses in New England as "a clear and unmistakable sign of an intent to remain—perhaps for a millennium."

Though no evidence has been found to confirm that Clark sought to replicate Cole's *Arcadian or Pastoral State* in his designs for the Clark Art Institute (fig. 8), the resemblance between Cole's painted landscape and Clark's architectural intervention is undeniable. As in Cole's painting, the green space that surrounds Clark's temple-like museum is designed to encourage museum visitors to wander through the manicured grounds and to take respite in the landscape. While in the museum, the windows of Clark's temple allow for visual connections, literally framing the designed landscape outside in relation to landscape paintings by French and British artists and other members of the Hudson River School inside. Tadao Ando elaborates upon this feature in his design for the Clark's expansion by reorienting the architecture from the street to instead face the expanse of the property. Though the architect is well known for his picture-frame wall cutouts, in the context of the history of colonial settlement and picture making in the region, the effect is a framing of the land itself as a landscape painting (fig. 9).

Like Cole's *Course of Empire*, this essay has quickly moved through 291 years to reveal some of the various mechanisms that transformed Mohican land, first by Williams into property, then by Cole into a landscape image, and finally into inhabitations of that image by Clark, as a progressive step into civilization. As visitors to the Clark, we are invited to occupy the materialized landscape image and unknowingly participate in the colonial logic that undergirds it. The ideology of property and the enduring image of civilization rewrites dispossession as a natural world order instead of as a coercive act. As dispossession is the obverse of property and property is an extension of landscape, to see landscape is also a way to *not* see dispossession. How, then, do we begin to not only see dispossession but to correct the historical injustice of it?

For decades now, analyses such as mine and others stemming from postcolonial and decolonial methodologies have revealed the ideologies that colonialism has impregnated within the land. In

27
Michael Conforti and Michael Cassin, *The Clark: The Institute and Its Collections* (London: Scala Art Publications, 2014), 50.

Dispossession as a Way of Seeing

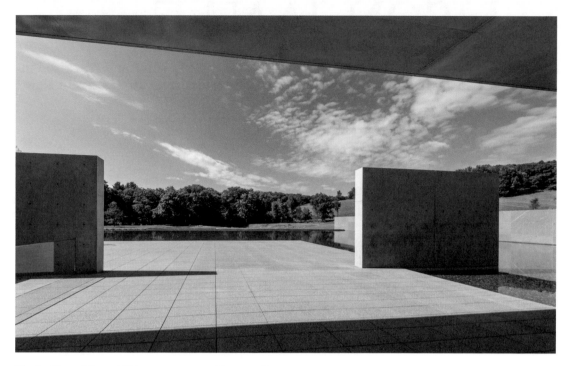

Fig. 9 View of Stone Hill (*background right*) from the Tadao Ando–designed Clark Center, 2014.

28
Alyssa Mt. Pleasant, Caroline Wigginton, and Kelly Wisecup, "Materials and Method in Native American and Indigenous Studies: Completing the Turn," *William and Mary Quarterly* 75, no. 2 (April 2018): 407–44.

the process of disentangling and revealing colonial mechanisms, the task of recuperating practices that have been silenced or erased is rarely undertaken. In other words, the colonial mechanism obscures relearning in the process of unlearning. My mentor in the field of Native American and Indigenous Studies, Kelly Wisecup, describes this problem as "an incomplete turn."[28] Wisecup and her collaborators Alyssa Mt. Pleasant and Caroline Wigginton outline ways to center Native voices and histories in scholarship. From their tribal lands in Wisconsin, the Stockbridge-Munsee Community Band of Mohican Indians have offered methods for "completing the turn" off the written page. In 2011, they purchased sixty acres of their ancestral homelands along the Hudson River, which now functions as an extension of their sovereign nation. Property, the means by which land was taken from them, becomes the means by which their ancestral land is taken back.

ALLISON JANAE HAMILTON

b. 1984, Lexington, KY; raised in
Florida; lives and works in New York

Allison Janae Hamilton's *Ouroboros* (2023) brings histories of ecological disaster in the southern United States to the northern Berkshires. Her outdoor installation presents two alligators coiled into an ancient circular form, mimicking the Egyptian symbol of a serpent who swallows its tail in an endless cycle of death and rebirth. The alligators were 3-D printed from body scans, finished with white automotive paint, and set on plinths on the covered porch outside the gallery—appearing as

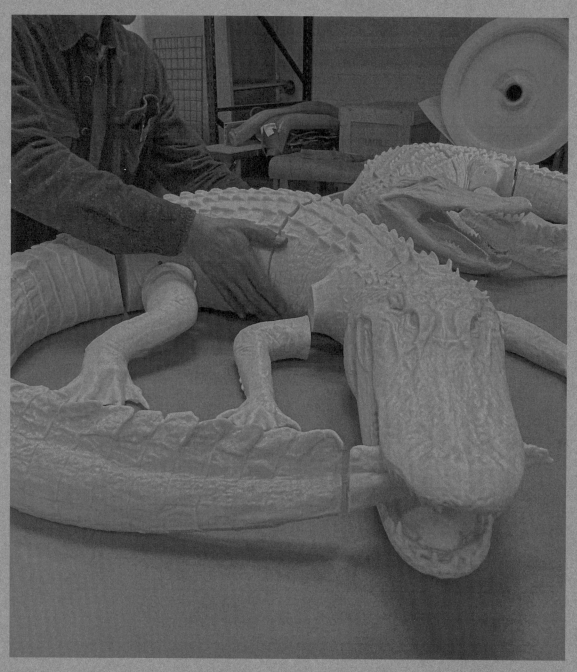

Allison Janae Hamilton, *Untitled (White Ouroboros)*, 2023. Polyethylene terephthalate glycol, paint, resin, 42 × 28 × 8 in. (106.7 × 71.1 × 20.3 cm); 45 × 29 × 8 ½ in. (114.3 × 73.7 × 21.6 cm).

Allison Janae Hamilton, *Blackwater Creature II*, 2019.
Feathers, hair, resin, various other materials, 13 × 24 ×
90 in. (33 × 61 × 228.6 cm).

unexpected visitors to the museum. The
creatures turn in opposite directions,
evoking the circular flow of the infinity
symbol or the eddies of ocean currents
that bring warm water north from the
Florida straits.

Hamilton was born in Kentucky and
raised in Florida. In sculpture, pho-
tography, and video, she draws on her
family's relationship to the rural South-
ern landscape to examine the legacies
of exploitative labor, natural resource
extraction, and the related effects
of climate change on the region. With
Ouroboros, the artist destabilizes con-
structed borders that neatly divide
the United States into north and south,
often casting the latter as a separate
world belonging to the past. Hamilton

suggests that *Ouroboros* might be a pair
of climate migrants, forced northward
by rising temperatures in their native habi-
tat. Indeed, in recent years, an alligator or
two has been spotted in Berkshire County.

Hamilton plays on the various associ-
ations that alligators carry in the South:
as sustenance, mythological figures, or
reminders of horrific racialized violence
(based on a legend that African American
infants were used as hunting lures). The
animals have been both predator and prey
in Hamilton's life; Hamilton recounts
being "endlessly watchful of alligators in
neighborhood canals." The artist has also
conjured alligators in other forms, as
haints, or supernatural beings that haunt
living creatures according to Hoodoo, the
syncretic African religion developed by

enslaved peoples in the South. Sculptures like Hamilton's *Blackwater Creature II* (2019), for example, with its loose combination of wood and metal, hair and feathers, are not naturalistic, but might bear a dreamlike relation to the gators.

The unexpected mobility of the alligators is, for Hamilton, a warning that climate disasters disproportionately weathered by rural Black Southerners also have the potential to migrate. Though *Ouroboros* suggests self-cannibalization, the act also promises rebirth. Hamilton's alligators are mythical, futuristic, and endlessly adaptive symbols of the resilience and persistence of those who have already survived disaster.

—BYG

Allison Janae Hamilton, *The peo-ple cried mer-cy in the storm*, 2018. Tambourines, steel armature, 18 × 3 × 3 ft. (5.5 x .9 x .9 m). Storm King Art Center, Windsor, NY.

Allison Janae Hamilton, *Alligator Creature*, 2021.
Taxidermy foam, sola wood, marble, bracken
fern, resin, paint, 30 × 32 × 20 in (76.2 × 81.3 ×
50.8 cm). Allison Janae Hamilton, *Wacissa*, 2019.
Single-channel video with sound, 22:14 min.
Installation view, Williams College Museum of
Art, Williamstown, MA.

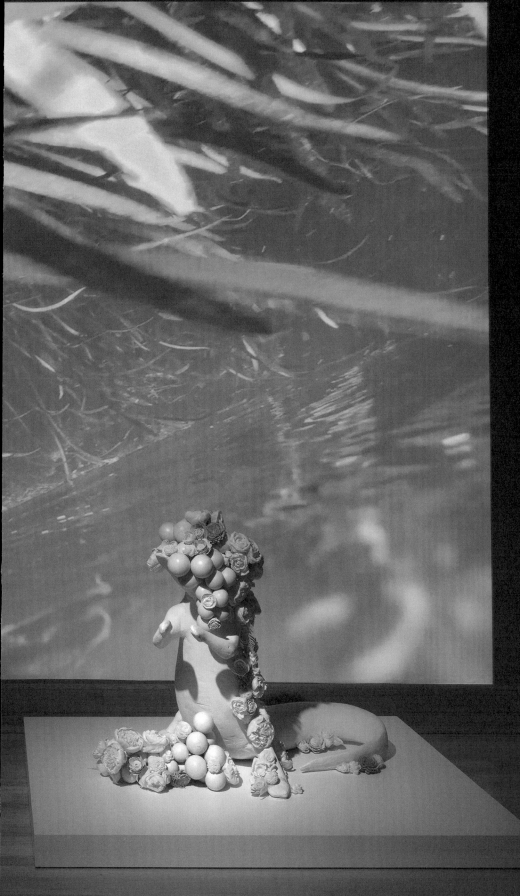

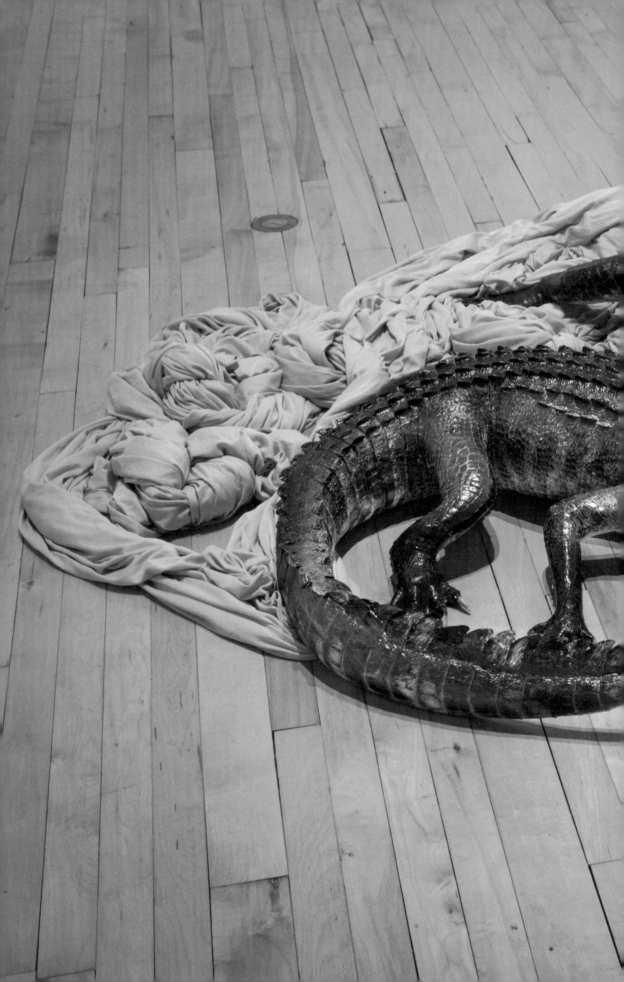

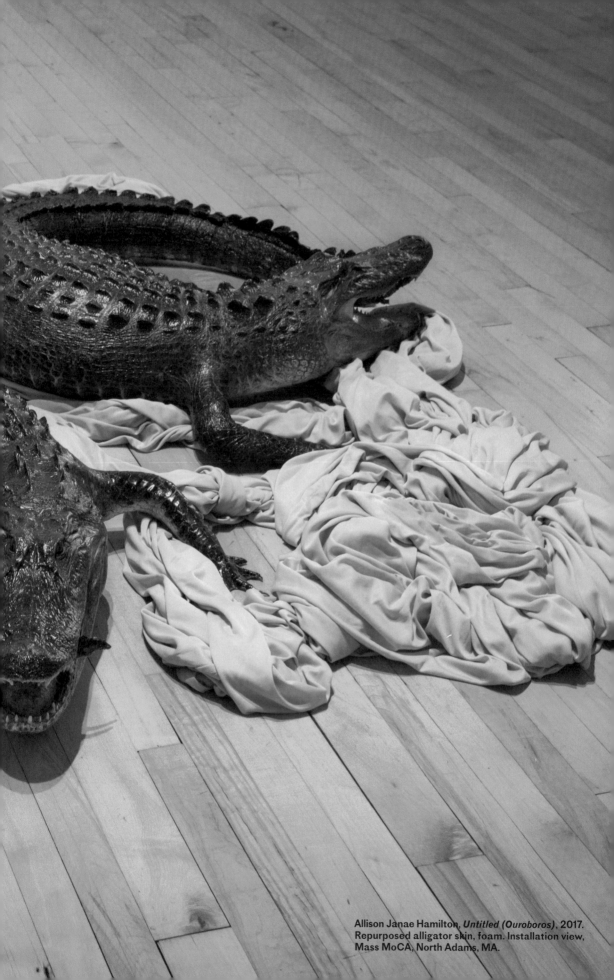

Allison Janae Hamilton, *Untitled (Ouroboros)*, 2017.
Repurposed alligator skin, foam. Installation view,
Mass MoCA, North Adams, MA.

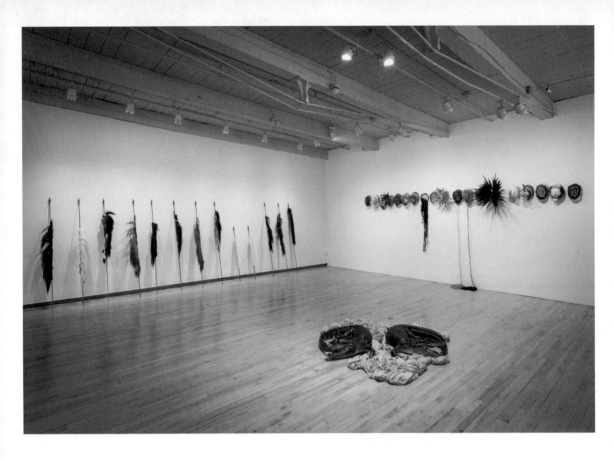

Allison Janae Hamilton, *Pitch*, 2018–19. Installation
view, MASS MoCA, North Adams, MA.

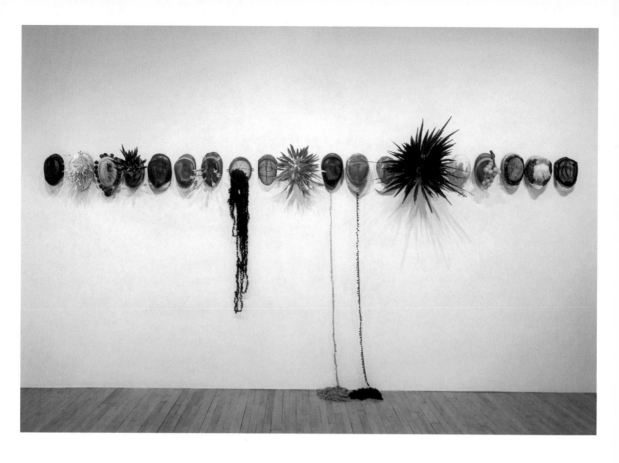

Allison Janae Hamilton, *Fencing Masks*, 2019.
Fencing masks, mixed media. Installation view,
Mass MoCA, North Adams, MA.

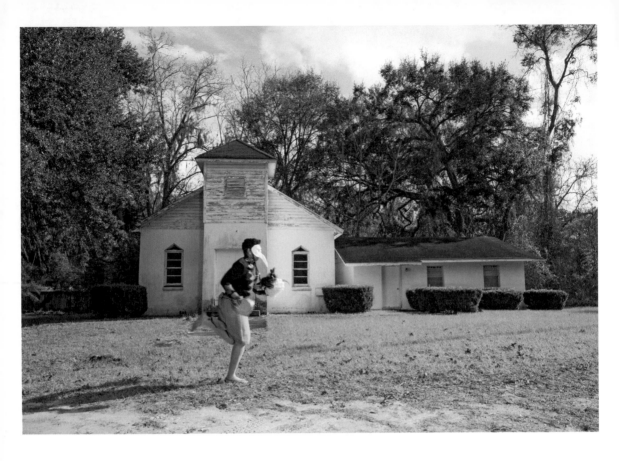

Allison Janae Hamilton, *Scratching the wrong side of firmament*, 2015. Archival pigment print, 40 × 60 in. (101.6 × 152.4 cm).

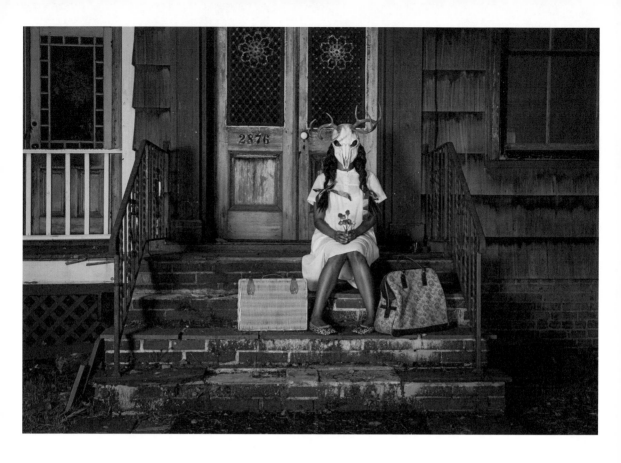

Allison Janae Hamilton, *The Hours*, 2015. Archival
pigment print, 40 × 60 in. (101.6 × 152.4 cm).

Allison Janae Hamilton, *Dollbaby standing in the orchard at midday*, 2015. Archival pigment print, 40 × 60 in. (101.6 × 152.4 cm).

Allison Janae Hamilton, *Brecencia and Pheasant III*,
2015. Archival pigment print, 40 × 60 in. (101.6 ×
152.4 cm).

JUAN ANTONIO OLIVARES

b. 1988, Bayamón, Puerto Rico;
lives and works in New York

Entering Juan Antonio Olivares's installation *Fermi Paradox III* (2023) is like setting foot on an uncharted planet. Twenty-one seashells hang from the ceiling at different heights; some, like a conch, might evoke nostalgia for beach days, while others appear profoundly alien. Abstracted from their marine context, these objects exist at both the macro scale of a solar system without a center and as microscopic organelles contained in the membrane of the gallery. Despite their evocation of life, the shells appear inert until, at closer proximity, one hears them.

Each of the shells is embedded with a micro-speaker connected to the wire from which it hangs, a strategy Olivares has employed in other sound installations, such as *Vespula Vulgaris* (2019), in which wasp nests buzz with disembodied voices. The audio of *Fermi Paradox III* is sequenced and controlled in three groups, creating a hushed and intimate soundscape that moves between shells in distinct phases. At times, the effect is spare, with a singular voice projecting into the void. At other times, low frequency droning and static effects invade the mix. The found audio clips form a dreamlike journey through the worlds of philosophy, science, literature, and beyond.

The work's title alludes to physicist Enrico Fermi's provocation that although there are billions of stars throughout the universe, some of which likely have Earth-like planets, humanity has yet to encounter intelligent extraterrestrial life. This now-famous observation has captured the imagination of scientists

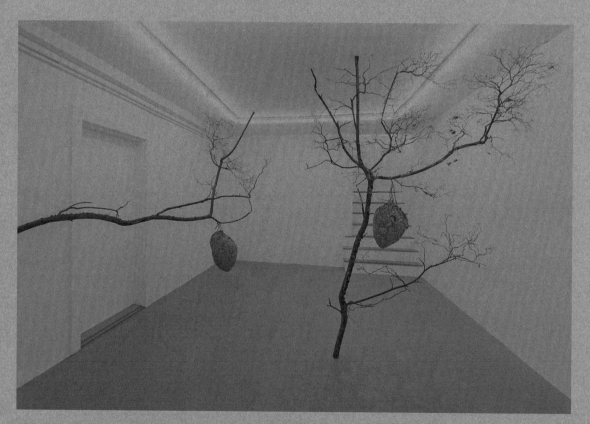

Juan Antonio Olivares, *Vespula Vulgaris*, 2019.
Five-channel sound installation, dimensions variable.
Installation view, Bungalow/ChertLüdde, Berlin.

Humane Ecology: Eight Positions

Juan Antonio Olivares, *Untitled (Fertilization)*, 2019.
Graphite on paper, 50 3/4 × 38 3/4 in. (128.9 × 98.4 cm).

and writers of science fiction for more than a half century, and it inspires the audio that Olivares samples. His eclectic sources include philosopher Arthur Schopenhauer, physicist Stephen Hawking, poet Gabriela Mistral, conspiracy theorist Bob Lazar, and singer-songwriter Nina Simone, among others.

In one passage, Simone's rendition of "Wild Is the Wind" is overlayed with a reading of philosopher Peter Wessel Zapffe's existentialist essay "The Last Messiah." Simone's longing, soaring vocals heighten a sense of loss in the narrator's reading of Zapffe's words: "the brotherhood of suffering between everything alive." Another of the work's most arresting moments comes as Hawking's voice emerges from the silence to ask, "Can you hear me? Why haven't we heard from anyone out there?"—a plea for company in a lonely universe, inflected by the synthetic tone of the physicist's text-to-speech system.

This marks the fourth iteration of Olivares's *Fermi Paradox* series since it began in 2016. The installation is sometimes accompanied by graphite drawings based on stock images of the microscopic biology of human reproduction, which resemble cosmic scenes. At the Clark, *Fermi Paradox III* appears in an airy gallery before a massive window wall, as wide and tall as the piece, filled with views of the lush forest beyond—a disjunctive environment in which to ponder what interstellar ecosystems might subsume our own.

—MG

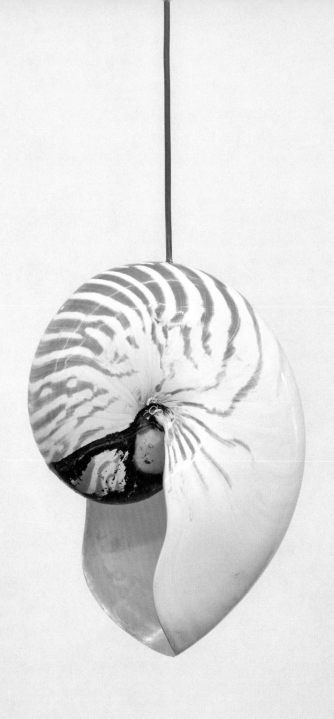

Juan Antonio Olivares, *Fermi Paradox III* (detail), 2019. *Echinocrepis rostrata* shell, *Cassis madagascariensis* shells, *Charonia tritonis* shells, *Lambis lambis* shells, *Nautilus pompilius* shells, *Melo aethiopica* shell, *Murex ramosus* shell, *Syrinx aruanus* shell, *Triplofusus papillosus* shells, *Porifera* sponge, surface transducers, micro-speakers, stereo amps, coaxial cables, polyolefin-coated speaker wire, SD cards, media players, 24-channel audio file (13:34), dimensions variable. Installation view, Bortolami, New York.

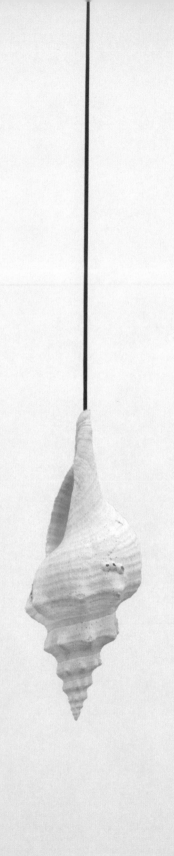

Juan Antonio Olivares, *Fermi Paradox III* (detail),
2019. Installation view, Bortolami, New York.

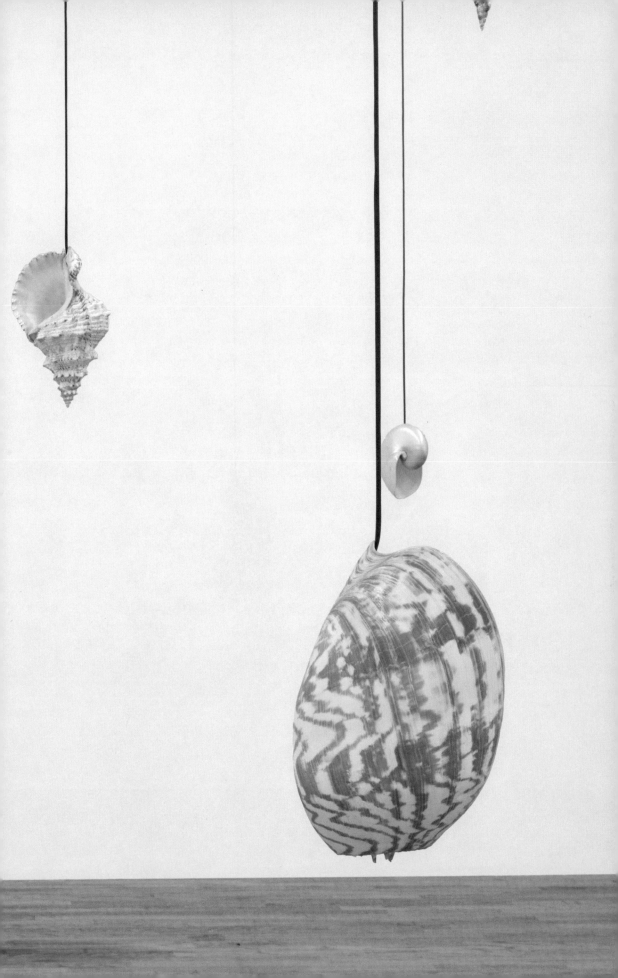

Juan Antonio Olivares, *Fermi Paradox III* (detail),
2019. Installation view, Bortolami, New York.

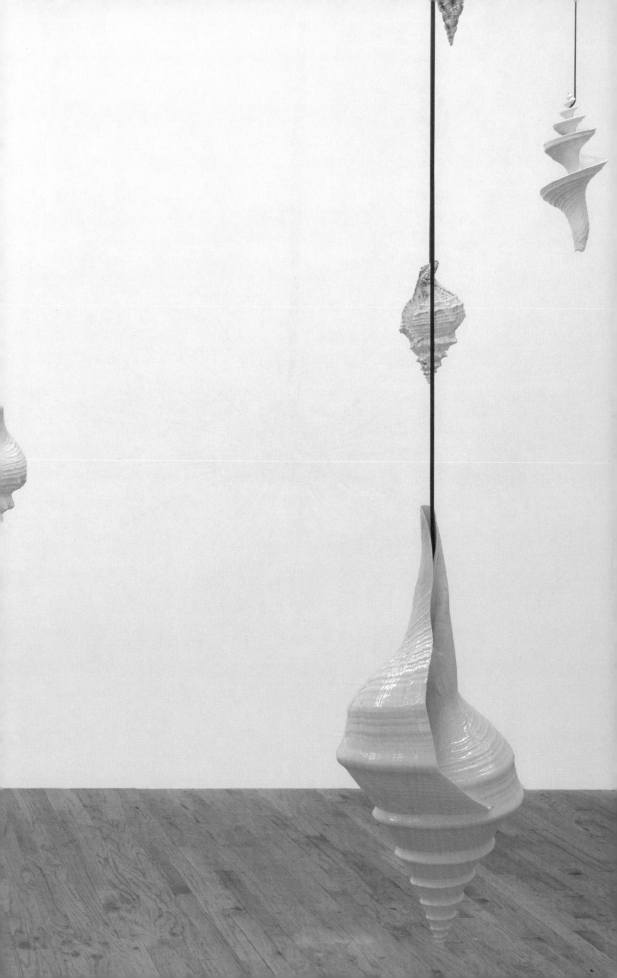

Juan Antonio Olivares, *Fermi Paradox III* (detail),
2019. Installation view, Bortolami, New York.

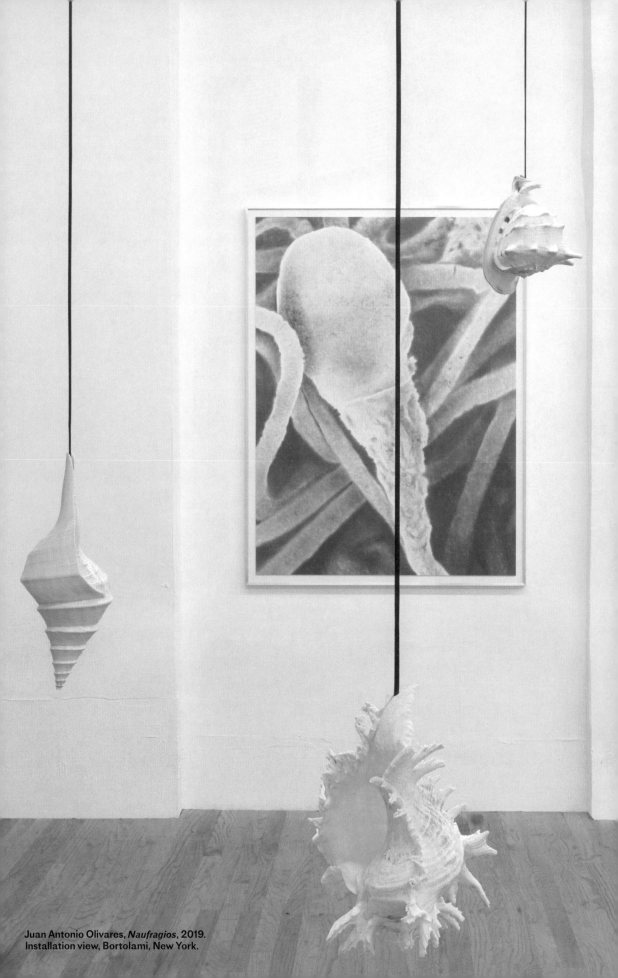

Juan Antonio Olivares, *Naufragios*, 2019.
Installation view, Bortolami, New York.

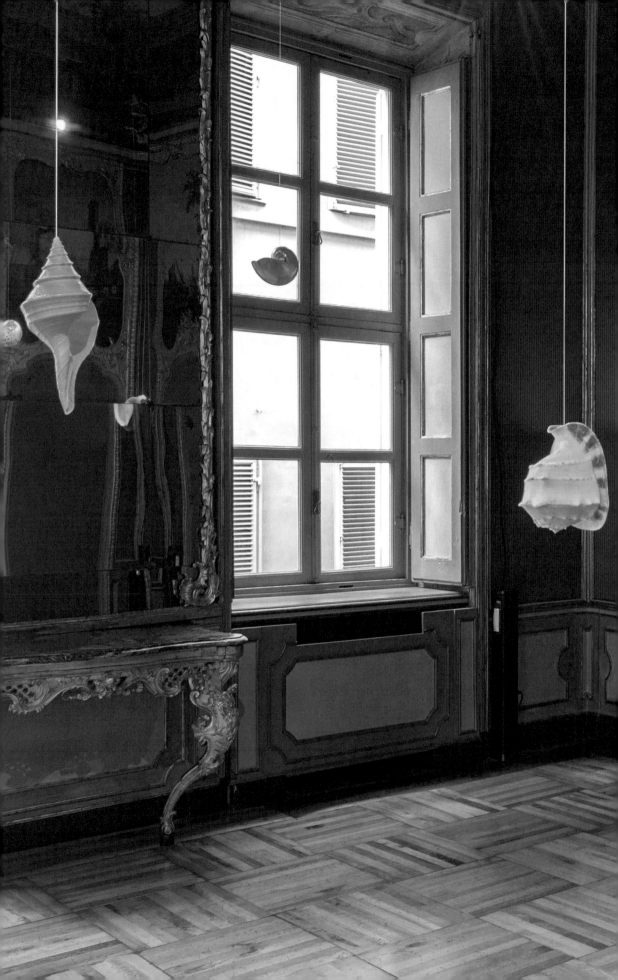

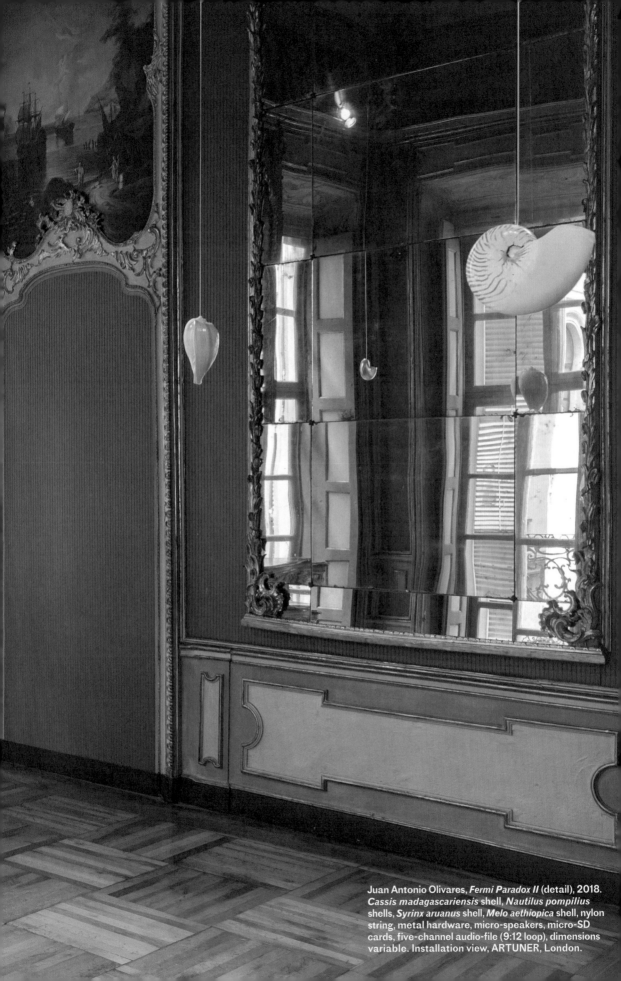

Juan Antonio Olivares, *Fermi Paradox II* (detail), 2018.
Cassis madagascariensis shell, *Nautilus pompilius*
shells, *Syrinx aruanus* shell, *Melo aethiopica* shell, nylon
string, metal hardware, micro-speakers, micro-SD
cards, five-channel audio-file (9:12 loop), dimensions
variable. Installation view, ARTUNER, London.

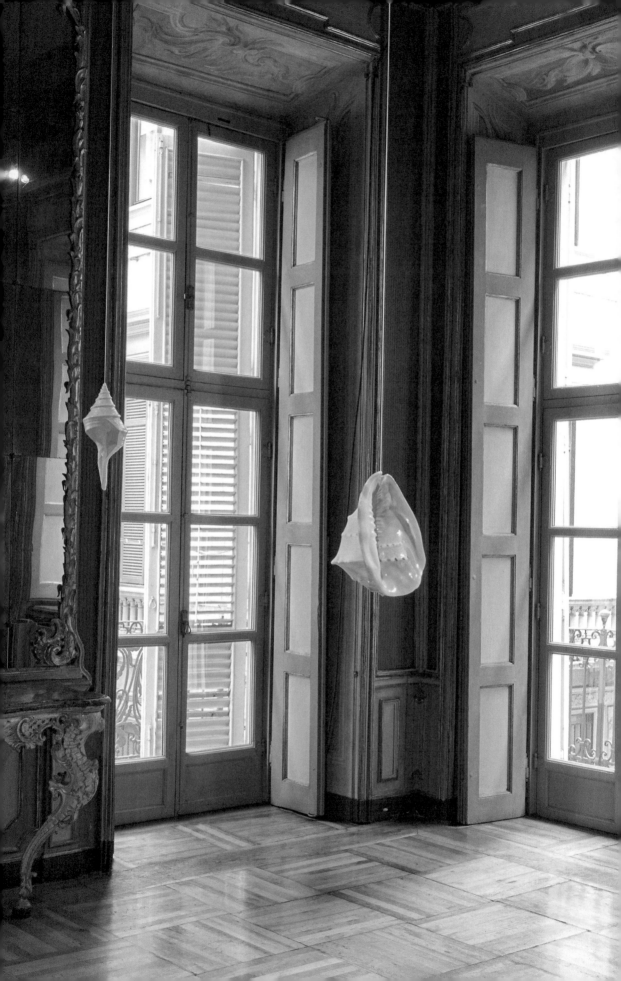

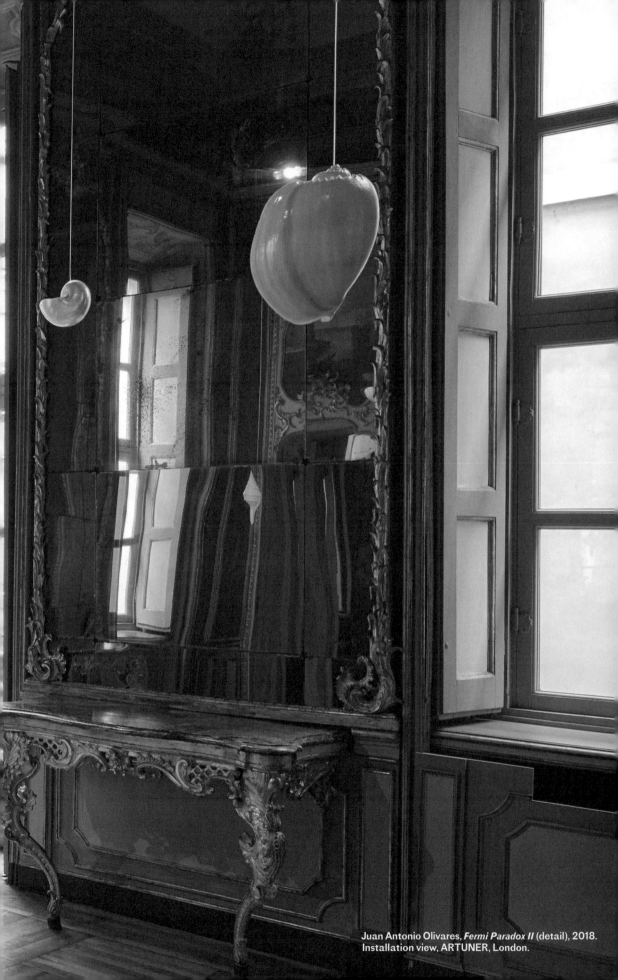

Juan Antonio Olivares, *Fermi Paradox II* (detail), 2018.
Installation view, ARTUNER, London.

NEW ECOLOGIES AND THE INVENTION OF LIFEWORLDS

Alena J. Williams

1
Octavia E. Butler, *Dawn* (New York: Warner Books, 1987). For a phenomenological account of human communicative acts, see Fred R. Dallmayr, "Life-World and Communicative Action" (working paper, Helen Kellogg Institute for International Studies, 1984).

2
Butler published *Dawn* just three years after Fred R. Dallmayr wrote "Life-World and Communicative Action" in 1984; two years before philosopher Félix Guattari's *The Three Ecologies* appeared in French in 1989; and three years before Michel Serres published *The Natural Contract* in French in 1990. Although it is not certain whether these authors had an awareness of one another's projects, I find it important to note this concurrence of ideas in Europe and North America. Félix Guattari, *The Three Ecologies*, trans. Ian Pindar and Paul Sutton (London: Athlone Press, 2000); Michel Serres, *The Natural Contract*, trans. Elizabeth MacArthur and William Paulson (Ann Arbor: University of Michigan Press, 1995).

3
Octavia Butler and Susan Palwick, "Imagining a Sustainable Way of Life: An Interview with Octavia Butler," *Interdisciplinary Studies in Literature and Environment* 6, no. 2 (Summer 1999): 153.

4
Even within the fields of speculative and science fiction, the notion of genre is a problematic one. For a critique of its inherent power differentials and its destructive potential as "a pernicious instrument of prejudice," see Ursula K. Le Guin, *The Birthday of the World* (New York: HarperCollins, 2022), 362.

5
Chelsea M. Frazier, "Troubling Ecology: Wangechi Mutu, Octavia Butler, and Black Feminist Interventions in Environmentalism," *Critical Ethnic Studies* 2, no. 1 (Spring 2016): 54.

This essay touches upon themes in environmental politics critically relevant for the work of contemporary artists today. It takes its departure from African American science-fiction writer Octavia Butler, whose 1987 novel *Dawn* treats the lifeworlds she invents as a malleable space of transformation.[1] Written amid the call for modes of ecological thinking in the wake of the deep ideological and ecological implications of the Manhattan Project's Trinity test and the Cold War, the first pesticides, and the 1970s oil crisis, Butler's post-apocalyptic novel was revelatory and prescient.[2] Her invention of new conceptions of living within and engaging with the world in *Dawn* was a response to the critical need to clear space for a new interrelation between humanity and its milieu. Highly theoretical in nature, Butler's writing intervenes in this hierarchical tendency by teasing out new propositions that amplify our embeddedness in planetary ecologies.

A radical figure in the literary field of science fiction, Butler made it clear during her lifetime that her literary approach was a political intervention and an open-ended speculation on humanity's evolutionary fate. She asserted that "humans have these two major characteristics, intelligence and hierarchical behavior, and hierarchical behavior is the older characteristic, all the way back to algae, and possibly further, and it tends to be in charge when you're not paying attention."[3] Butler's ecological thinking in *Dawn* marks the incipient nexus of art and ecology in the three decades emerging after the environmental movement of the late 1960s. Yet, taking a retrospective look onto the intersection of art and environment requires letting go of traditional distinctions of genre.[4] The genre of science fiction proposes new spaces of creation and invention—as well as participatory structures and exchange between dissimilar entities—highly relevant to artistic practices at the center of this essay, which do not sit squarely within the institution of art. The creative activity of a generation of artists from the 1960s and 1970s highlighted here reflect what scholar Chelsea Frazier calls Butler's "ecological ethics"—that is, unprecedented ways of working at the intersection of political ecology and speculative forms of contemporary life.[5]

LIVING TECHNOLOGIES
In the opening chapters of Butler's novel, its main protagonist Lilith Iyapo awakes from a long slumber as one of a few earthly survivors who must prepare for reacclimating to the planet in the wake

Fig. 1 Ana Mendieta (Cuban American, 1948–1985), *Untitled*, from the series *Silueta Works in Iowa*, 1978. Silver gelatin print, 19 1/2 × 15 1/2 in. (49.53 × 39.37 cm). Collection SFMOMA, Accessions Committee Fund: gift of Collectors' Forum, Emily L. Carroll, Jerome S. Markowitz and Maria Monet Markowitz, and Judy C. Webb, © Estate of Ana Mendieta Collection, LLC, courtesy of Galerie Lelong & Co. Licensed by Artists Rights Society (ARS), New York.

of a nuclear war. The first word uttered in the text is "Alive!" A fitting beginning for Lilith's revival, years after a near extinction of humanity. Yet, she is not alone. Aboard a spaceship hovering just beyond the Moon, Lilith owes her survival to two symbiotic nomadic species; they have prolonged her life by engaging the matter of the universe in creative ways. While her new extraterrestrial "companion species" guide her through the spaceship's many chambers and spaces, Lilith encounters the vertical structure of a tree.[6] In this moment, she recognizes the spaceship as both an engineering technique and a living entity. Reaching "out to touch its smooth, slightly giving bark—like the walls of her isolation room" in which she first awoke—Lilith asks, "These trees are all buildings, aren't they?"[7]

Here, Butler explores technological form and how it might take shape as a symbiotic being, undercutting the commonplace assumption that nature and technology are entirely disparate, and sentient and inanimate materials are oppositional. In *Dawn*, the distinction between sentient and inanimate materials loses its fixity in this strange environment—Lilith's encounter

6
For a discussion of "companion species," see Donna J. Haraway, *The Companion Species Manifesto: Dogs, People, and Significant Otherness* (Chicago: Prickly Paradigm Press, 2003).

7
Butler, *Dawn*, 35.

8
Darren Incorvaia, "This Is What It Sounds Like When Plants Cry," *New York Times*, March 30, 2023. See also Itzhak Khait et al., "Sounds Emitted by Plants under Stress Are Airborne and Informative," *Cell*, March 30, 2023.

9
This term, and Butler's trilogy, resonates with the work of several contemporary artists and cultural theorists, including the British collective the Otolith Group. There is not enough space here to interpolate between Butler's "xenogenesis" and Félix Guattari's conception of "heterogenesis," however, these ideas and influences speak to the greater polysemic possibilities of thinking through difference. Guattari's English translators describe heterogeneity as "an expression of desire, of a becoming that is always in the process of adapting, transforming and modifying itself in relation to its environment." Translators' introduction to Guattari, *The Three Ecologies*, 90n49. See also the Otolith Group and Megs Morley, eds., *The Otolith Group: Xenogenesis* (Berlin: Archive Books, 2022).

10
Butler, *Dawn*, 61. This trope can also be found in subsequent Butler-influenced Afrofuturist fiction, such as author Nnedi Okorafor's 2014 *Lagoon*, set off the coast of Lagos, where nonhuman beings "appear to be made up of many individuals." Scholar Melody Jue likens them to the multispecies environment of coral reefs. Melody Jue, "Intimate Objectivity: On Nnedi Okorafor's Oceanic Afrofuturism," *WSQ: Women's Studies Quarterly* 45, no. 1 (2017): 179–80; see also Melody Jue, *Wild Blue Media: Thinking through Seawater* (Durham, NC: Duke University Press, 2000).

with the trees on the spaceship reflects a deeper understanding of how one might relate to the world anew in this novel ecological context. Yet, trees are what first gestured humanity toward the replication of their forms in works of engineering on small and large scales. Kaleidoscopic in nature, trees modulate light; at the same time, they internalize light through photosynthesis—all of which reflect their ways of subsisting, thriving, and surviving in the world. What if plants communicated to us in ways we might readily understand?[8]

Much like Butler's practices, connections between plant and human life also appear in artist Ana Mendieta's work as speculative proposals. Mendieta began her *Silueta* series (1973–80)—performative actions in sculpture, photography, and moving image—while studying art at the University of Iowa (fig. 1). Transposing Yucatecan Indigenous spirituality to the vicinity of Iowa City, in some works she captured the incrustations of dirt and mud on her body, as well as their own material and psychic relation to this new context. For Mendieta, the Spanish word *silueta* ("silhouette" in English) refers to an outline, imprint, and, at times, a mound referencing a corporeal form. Exemplifying this exchange between corporeal form and the physicality of ecological contexts in sites such as Mexico, Cuba, and Iowa, Mendieta's body enters a kind of visual language in this series, but also the sign's own materiality has significance. As shadows cast, or traces left behind, the works reflect the intensely intermedial nature of the artist's submergence in her environment. Mendieta's rendering of the *silueta* in sand, soil, vegetal growth, water, fire, gun powder, paint, and blood, among other materials, collapses the separation between form and sign. Once the artist retreats, the works constantly transform the boundaries of relation—the water at the edge of a seascape gradually alters the form, sending it back into oblivion.

These ideas of exchange with living nature can also be found in Butler's *Xenogenesis* trilogy, of which Dawn is a part. The term *xenogenesis* refers to creation from outside the body; it is a symbiosis that thrives on difference and reinforces the bonds between all things.[9] As one Oankali, the extraterrestrial beings of *Dawn*, tells Lilith: "Six divisions ago, on a white-sun water world, we lived in great shallow oceans We were many-bodied and spoke with body lights and color patterns among ourself and among ourselves."[10] The Oankali once lived symbiotically with other species, and only

Fig. 2 Ana Mendieta, *Árbol de la Vida* (*Tree of Life*), 1976. Color photograph. © Estate of Ana Mendieta Collection, LLC, courtesy Galerie Lelong & Co., licensed by Artists Rights Society (ARS), New York.

spoke of themselves as plural subjects. Signaling the drawbacks of "hierarchical behavior," Butler speculates on humanity's evolutionary fate in the face of its own imminent extinction. In Butler's telling, procreation is not only between three beings in *Dawn*, but is reflective of a larger multi-species history. Scholars often mobilize Donna J. Haraway's innovative work in rethinking the relations between humans and other life-forms in feminist science and technology studies.[11] The xenogenesis that Butler theorizes is not merely a meeting of minds, but a conception of touch and sensation as the critical intermediary mobilizing the social relation of interspecies procreation.[12]

Mirroring vegetal form, Mendieta invents and creates life. In *Árbol de la Vida* (1976), Mendieta covered her unclothed body with wet earth, leaning, arms raised at ninety-degree angles, against the trunk of a very large tree (fig. 2). Due to the deep erosion of the bank of the stream where the tree sits, its root system appears as a horizontal section. Reaching outward, the massive plant is not unlike the *Ficus elastica*, a rubber tree species molded into bridges in India's Meghalaya state

11
See Donna J. Haraway, *When Species Meet* (Minneapolis: University of Minnesota Press, 2008).

12
Scholar Lisa Dowdall points out: "Butler positions human identity as something flexible and manifold, rather than something defined by the juxtaposition of the self in relation to the other." Lisa Dowdall, "Treasured Strangers: Race, Biopolitics, and the Human in Octavia E. Butler's Xenogenesis Trilogy," *Science Fiction Studies* 44, no. 3 (November 2017): 517.

New Ecologies and the Invention of Lifeworlds

13
Wilfrid Middleton et al., "Characterizing Regenerative Aspects of Living Root Bridges," *Sustainability* 12, no. 8 (2020): 3,267.

14
Michael Taussig, "The Language of Flowers," *Critical Inquiry* 30, no. 1 (Autumn 2003): 112; emphasis my own.

15
Mrinalini Mukherjee quoted in Andrew Gardner, "Mrinalini Mukherjee: Textile to Sculpture," *Post: Notes on Art in a Global Context* (December 11, 2019), https://post.moma.org/mrinalini-mukherjee-textile-to-sculpture/.

16
According to philosopher of science Georges Canguilhem, the idea of "milieu" appears in the work of mathematician Isaac Newton; however, he argues the term has had a variety of conceptions in the eighteenth and nineteenth centuries, particularly in the French intellectual tradition. See Georges Canguilhem, "The Living and Its Milieu," in *Knowledge of Life*, ed. Paola Marrati and Todd Meyers, trans. Stefanos Geroulanos and Daniela Ginsburg (New York: Fordham University Press, 2008), 101. See also Jue's "milieu-specific" reading of oceanic media and oceanic narratives, in Jue, *Wild Blue Media*, 32.

17
Butler, *Dawn*, 129.

18
Butler, *Dawn*, 201.

that operate like a "vernacular living architecture."[13] Like mandrakes—a Mediterranean plant with a substantial root system that resembles a human figure (scholar Michael Taussig describes them as "hovering between an art *of* nature and an art *in* nature")—the *Ficus elastica* shape responds to human touch, reflecting its own creative responses to environmental conditions and stimuli.[14] Mendieta's *Árbol de la Vida* is thus a reflection of the potential interchangeability and creative exchange between bodies in space, generative nature, and evolving frameworks, unfurling like the hemp knots of artist Mrinalini Mukherjee, which signal that—in the artist's words—"my body, my materials, the way of life, the environment, all work together."[15]

MILIEU

"Milieu" is a concept that captures not only the ecological context of any given organism, but also the myriad relations within it.[16] Negotiating milieu between discrete biomes and their boundaries is about moving between spaces of difference, like moving between the contemporary metropolis and the natural world.

It is hardly incidental that in Butler's *Xenogenesis* trilogy the Amazon basin is the future site of humanity's return to a radically transformed planet, in which "there are no more cities."[17] For Butler's Oankali, any "simulation of a tropical forest of Earth had to be complete with snakes, centipedes, mosquitoes, and other things Lilith would have preferred to live without."[18] Biomes like the tropical rainforest, where the environment assumes readily tangible forms—frequent precipitation, dense vegetation, and an abundance of biological forms all within a colorful and complex space— are spaces where an immersive understanding of habitation on Earth is most evident. The Amazon basin's larger ecological context (made up of nine contiguous nation states in South America) has always been a space in which cultural production occurs within and outside of its vast and differentiated environment.

In the wake of large-scale urban sprawl, the relation between the great expanse of the Amazon basin to the south and the city of Caracas in Venezuela to the north is crucial in the artist Milton Becerra's work, including *Una cobija para la hierba* (A blanket for the meadow; fig. 3) and *Camino* (Path; 1978). Made in collaboration with artist Luis Villamizar, these works symbolize human encroachment upon the verdant environment in the Caracas

Fig. 3 Milton Becerra (Venezuelan, b. 1951), *Una cobija para la hierba*, 1974–75. © the artist / ADAGP Paris / Article L122-2.

suburbs. The artists covered a rock in gestures and forms, first with pigment and then with red, yellow, blue, and green fabrics. As architect Paulo Tavares has shown, vegetation can unexpectedly reveal traces of our engagement with nature. Writing on his research on the ancient settlements of the Indigenous communities of the Xavante in the Amazon basin, Tavares asks: "Can we claim trees, vines, and palms to be historic monuments?"[19] In the space between inhabitable and uninhabitable environments, differentiations and distinctions within liminal zones become both heterogeneous and indistinguishable.[20] Such relationships emphasize the way these liminal zones reflect a constant negotiation of boundaries.

Tavares's video essay *Nonhuman Rights* (2012) opens with a wide shot of the Ecuadorian Amazon. Milky white fog rises and caresses the elevated peaks of mountains covered in vegetation. Due to the low level of light, the image is desaturated, and it is difficult to make out the color of its surface

19
Paulo Tavares, "Trees, Vines, Palms and Other Architectural Monuments," *Harvard Design Magazine* 45 (2018): 194.

20
Environmentalist Rachel Carson discusses the way the oceans and atmosphere of the whole Earth is part of one large dynamic system. See Rachel Carson, *The Sea Around Us* (New York: Oxford University Press, 1951).

New Ecologies and the Invention of Lifeworlds

21
Serres, *The Natural Contract*. I
am indebted to the expansive the-
oretical and aesthetic research
of Tavares for introducing me to
this work by Serres. Serres ana-
lyzes Francisco Goya's painting
Duel with Cudgels, or *Fight to the
Death with Clubs* (1820–23) within
a larger critique of the geopoliti-
cal blindness toward nonhuman
agents in the world. The paint-
ing depicts two men engaged in
combat while oblivious to the
rising water slowly threatening to
envelop them. Part of the *Black
Painting* series (oil murals pro-
duced toward the end of his life
within his home), *Duel with Cudgels*
is as obscure as the circumstances
captured in the scene itself; there
is some debate as to whether the
original painting depicted a field
of grass or a body of water—and
whether the work is attributable
to Goya at all. See Paulo Tavares,
"Nonhuman Rights," in *World
of Matter*, ed. Inke Arns (Berlin:
Sternberg Press, 2015), 48–59.

22
Ava Woodgrift, an undergraduate
at the University of California,
San Diego, noted that the ambient
sounds on the soundtrack of
Tavares's *Nonhuman Rights* sounded
like the earth was breathing.

blanketed with foliage. It is as if the moisture
emerges from the landscape. On the soundtrack
we hear the wind buffeting a microphone and the
intermittent sounding of a bird's call. In voice-
over narration, Tavares recounts the historical
and ecosophical conditions of Michel Serres's
1990 publication *The Natural Contract*—an
impassioned appeal against human aggression
in the immediate aftermath of the Cold War—in
favor of nature becoming a subject on equal footing
with humanity.[21] Interlaced between the images
and the spoken word lies Tavares's interpretation
of Serres—a mediation of quotations from Serres's
text, which he introduces on white title cards.
Inverting Butler's critique of "hierarchical think-
ing," Tavares surmises that "humanity has turned
into the equivalent of a natural force." Have we
actually approached the enormous generative
capacity of planetary forces?

Much like trees, as we breathe, we transform
the very composition of the air around us. Here,
it is imperative to return to the work of Mendieta.
Mendieta's filmed performative action *Untitled
(Grass Breathing)* (1974) captures this idea elo-
quently: lying beneath a surface of topsoil and
grass, the circulation of her respiratory system
slowly elevates the earth entombing her. And
yet the film suggests that the earth itself is breath-
ing—each breath fluctuates between liveliness and
death.[22] In *Nonhuman Rights*, Tavares says, "these
images are not metaphors … from the perspec-
tive of global systems we, together, resemble the
behavior of the seas." With this latter phrase,
the image cuts to another wide shot, this time of
a massive cityscape with a seemingly endless
grid of skyscrapers and architecture. When the
perspective shifts in the subsequent view, one
can discern a major thoroughfare bisecting the
screen, a reflection of flashing light as cars rush
by appears. Tavares continues, "as winds blow and
change the weather, humanity has assumed the
power to change the climate." Under the com-
pounded refraction of the telephoto lens, the image
scintillates, capturing the distorting effects of
the heat radiating from the urban matrix. One
cannot help but think of the juxtaposition between
nature and the encroaching urban settlement
Becerra demarcates in his works in Caracas: Is
this, too, not a battleground?

Embodying this dual nature of terrestrial life
within and amid the Earth's hydrosphere, artist
Fujiko Nakaya's fog installations reflect upon how
routine acts of transformation occur in the atmo-
sphere infinity-fold. Nakaya worked with engineers

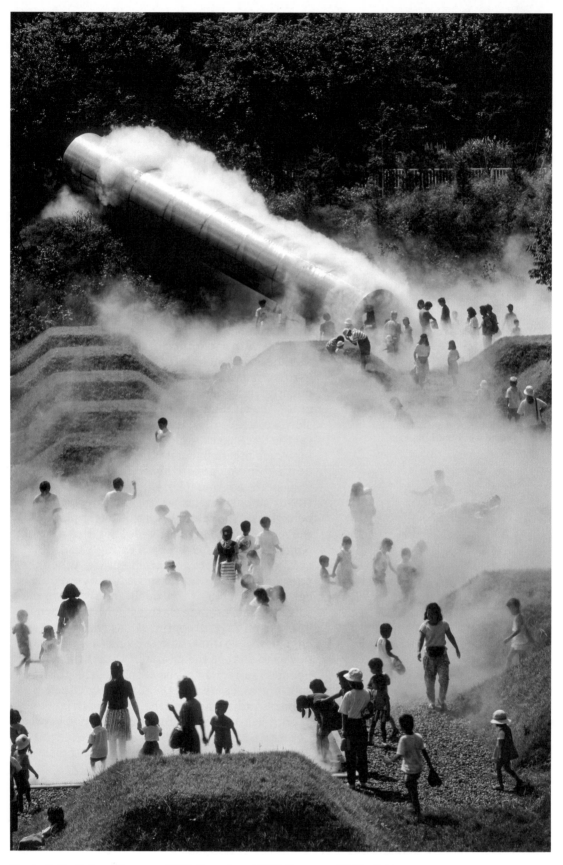

Fig. 4 Fujiko Nakaya (Japanese, 1933), *Foggy Forest*, 1992. Courtesy of Fujiko Nakaya.
Photo by Shigeo Ogawa/Shinkenchiku-sha.

Fig. 5 Fujiko Nakaya, *Experiments in Art and Technology's Pepsi Pavilion at the 1970 Japan World Exposition, Osaka*, 1970. © J. Paul Getty Trust, Getty Research Institute, Los Angeles, CA, 2014.R.20. Photo by Harry Shunk and Janos Kender.

as part of the free-wheeling and expansive non-profit Experiments in Art & Technology. For Expo '70 in Osaka they created a permeable installation of controlled atmosphere. Nakaya became internationally known for developing large-scale fog works guided by two impulses: to simulate nature's mechanisms and to comment on the world through representation (figs. 4 and 5). What we see in these works is the visual boundary between fluids of differing compositions and temperatures. Creating fog involves changing the physical state of liquid molecules suspended in air by controlling their behavior. Billowing, cooling, condensing, dissipating—these pieces, whose formal composition constantly transforms as water vapor rises and ultimately dissipates into the larger fluid body of air, underscore their own amorphous physicality.

Regaining consciousness after periods of sleep aboard the spaceship, Lilith experiences the act of "Awakening" in Butler's *Dawn*. Lilith's inner voice speaks to her state of "survivance"—what Minnesota Chippewa member and scholar Gerald Vizenor calls the act of resisting and thriving in

the now in the wake of oppression.[23] "It was a struggle to take in enough air to drive off nightmare sensations of asphyxiation. Lilith Iyapo lay gasping, shaking with the force of her effort."[24] Herein lies the paradox of life, which emerges as a matter of course within specific ecologies: given humanity's constant immersion in air, air's exact composition goes unnoticed unless its critical ratio of oxygen to other substances and gases shifts. Each breath bespeaks the biochemical relations of the planet and the constant changing of its constitution as it condenses over the ocean and water precipitates over land and sea.

Although distinct from the speculative ecologies envisioned by Butler, artist Betty Beaumont's *Ocean Landmark* (1980; fig. 6) advances how industry might return forcibly extracted natural resources back to the planet—albeit in an altered form. Beaumont placed *Ocean Landmark* just off the coast of the northeastern seaboard of the United States, in a radical gesture of ecological remediation. As Beaumont described: "I processed 500 tons of an industrial waste product, laid it on the floor of the Atlantic and created a flourishing environment no one can see."[25] As a fossil fuel, coal waste—the residual matter and heavy metals that coal mining leaves behind—is a key

23
Gerald Vizenor, *Manifest Manners: Narratives on Postindian Survivance* (Lincoln: University of Nebraska Press, 1999); and Gerald Vizenor, *Native Liberty: Natural Reason and Cultural Survivance* (Lincoln: University of Nebraska, 2009).

24
Butler, *Dawn*, 3.

25
Betty Beaumont, "Decompression: A Living Laboratory in Cyberspace," in *MULTIMEDIA '00: Proceedings of the 2000 ACM Workshops on Multimedia*, ed. Shahram Ghandeharizadeh et al. (New York: Association for Computing Machinery, 2000), 9.

Fig. 6 Betty Beaumont (Canadian American, 1946), *Ocean Landmark—The Object*, 1979. 17,000 3/4 × 3/4 × 1 ½ in. blocks. *Ocean Landmark—The Object* was created to gain a sense of scale for the massive *Ocean Landmark* underwater sitework and is a tangible reminder of something invisible but real.

26
Beaumont, 10.

27
See Julia Watson, *Lo-TEK: Design by Radical Indigenism* (Cologne: Taschen, 2020), 350–67. In the book, Maximin K. Djondo, director of the Benin Environment and Education Society, points out that "due to unsustainable fishing in the last couple of decades, only the few who have money to build and maintain *acadja* are benefitting. This is creating community conflict and preventing the majority from getting access to common sources." Watson, 375.

28
According to Martin Kemp, "it is listed as a 'fish haven' by the National Oceanographic and Atmospheric Administration." He cites Beaumont's own statements: "Using global positioning satellite technology, the work can be located and images created through the use of underwater remote sensing and side-scan sonar." Martin Kemp, "Betty Beaumont's *Ocean Landmark* Is in Deep Water," *Nature* 431, no. 1,039 (2004), https://www.nature.com/articles/4311039a.

29
For further study on legal proceedings and the environment as witness, see Paulo Tavares, "Murky Evidence: Environmental Forensics in the Age of the Anthropocene," *Cabinet Magazine* 43 (Fall 2011): 103.

component of carbon molecules that appear in the air. In video documentation of the work, only a large barge is visible as it moves in the waters of the New York Bight, where the land juts sharply inland along the continental shelf off the coast of Long Island. Beaumont recycled 17,000 coal fly-ash blocks, releasing them from a massive ship, which then fell through nearly 164 feet of seawater to the base of the continental shelf.[26]

Ordinarily, such material contaminates the land after processing—or the air after its producers burn it. Combustion oxidizes the carbon into carbon dioxide, a major component of global warming by way of the greenhouse effect. Repurposing this material by casting it into cinder blocks—a decidedly low form of material—Beaumont consigned it to a murky future in the depths of the Atlantic Ocean. The sand, detritus, and biological matter comprising the underwater seascape reveal their own transformation as a result of their proximity with this coal waste. These life worlds, too, could have once been humanity's adapted habitat rather than land. Contemporary villages like Ganvie in Lake Nokoué, Benin, where *acadja* (submerged installations of tree branches that attract fish and wildlife) and boats form the architecture, remind us that much of humanity could have easily evolved as an aquaculture.[27]

Yet, the crux of Beaumont's project, as art historian Martin Kemp has pointed out, rests on the potential inaccessibility of the work to the viewer—a circumstance that increases the longer it remains interred at the bottom of the Atlantic Ocean. *Ocean Landmark* exists in the form of artifacts and documentation, and what glimpses remote sensing technologies might possibly bear of a community of marine life that thrives amid the submerged earthwork.[28] Although situated at the margins of human perception, *Ocean Landmark*'s wealth of nonhuman witnesses exceeds that of the human eye, which becomes significant particularly in connection to accountability and the law.[29] It opens questions like: Who bears witness to the activities by which humanity makes space for itself? *Ocean Landmark* proposes that artistic research might create alliances with scientists and industrialists of mutual benefit to humans and other life-forms.

TOUCH AND THE SOCIAL
Each of *Dawn*'s four sections—"Womb," "Family," "Nursery," and "The Training Floor"—capture Butler's recurring focus on the way sensation

Fig. 7 Mierle Laderman Ukeles (American, b. 1939), *Touch Sanitation Performance,*
1979–80, March 24, 1980. Courtesy the artist and Ronald Feldman Gallery, New York,
© Mierle Laderman Ukeles. Photo by Deborah Freedman.

mediates space. Although scientific investigations into the natural world hint at an expansion of human understanding, these encounters are merely probative, experimental, and transitory. In *Dawn*, Butler conceptualizes the Oankali spaceship as biochemically connected to its inhabitants by way of physical touch. Inside the spaceship, when Lilith places a "sweaty hand" on an image of one of the human survivors she plans to revive, the enactment of touch is chiefly about "renewing her own chemical signature."[30] After having engaged with the environment since Lilith's awakening, it "responded to her touch now by growing inward along a line of her sweat or saliva drawn along the floor."[31] For a contemporary reader, this biochemical connection between a body and a seeming inanimate object or surface might seem unnatural, but humanity's routine disconnection from things in the world, including one's own waste, as viewed from the perspective of the Oankali, might be equally strange.

It was while caring for her child—attending to nutrition, digestion, and cleanliness—and navigating her existence as mother and artist that Mierle Laderman Ukeles made her landmark work, *Touch Sanitation* (1978–80). Ukeles recognized her "own personal fury—as a mother maintenance worker" of how the employees of municipal sanitation departments, house cleaning staff, and home caregivers are "not heard … not honored, dumped outside the culture."[32] Ukeles systematically met and shook hands with thousands of sanitation workers as an ongoing performance to undercut the false hierarchy between sanitation workers and the rest of society. Ukeles's embracing of hands—a gesture that launched her position as artist-in-residence at the City of New York's Department of Sanitation (figs. 7 and 8)—became symbolic, a form of mutual recognition that rejects structural and institutional hierarchies. Ukeles's project was driven by an ethos that much like the intensely fragile micro-ecology of newborn children, the ecology of the city would critically breakdown without the removal of its waste.[33]

Until 1895, state and municipal agencies in New York City routinely cast off waste into the Atlantic Ocean, despite the milieu of the metropolis being one great ecological context.[34] It was a reckless practice that continued until the state of New Jersey filed a court order against it that the US Supreme Court subsequently upheld; by 1965, the new federal Solid Waste Disposal Act empowered states, and municipalities therein, to enact codes and policies to mitigate the accumulation of

30
Butler, *Dawn*, 127.

31
Butler, 125.

32
Mierle Laderman Ukeles, "Touch Sanitation: A NYC Citywide Performance" *WEAD Magazine* 12 (October 2021), https://directory. weadartists.org/touch-sanitation.

33
Mierle Laderman Ukeles in conversation with the author, November 2010, at the City of New York's Department of Sanitation.

34
See Yana Manevich, "A Timeline of Solid Waste Management in New York City," *Shaping the Future of New York City* (course website), March 17, 2013, https://eportfolios. macaulay.cuny.edu/macbride13/ research/a-timeline-of-solid-waste-management-in-new-york-city/.

Fig. 8 Mierle Laderman Ukeles, *Touch Sanitation Performance, 1979–80*, November 20, 1979. Courtesy the artist and Ronald Feldman Gallery, New York, © Mierle Laderman Ukeles. Photo by Tobi Kahn.

35
The federal Solid Waste Disposal Act conceded that "the continuing technological progress and improvement in methods of manufacture, packaging, and marketing of consumer products has resulted in an ever-mounting increase, and in a change in the characteristics, of the mass material discarded by the purchaser of such products." Solid Waste Disposal Act, Section 1002 (a)(1), page 3. In 2001, New York City closed the last of its landfills, Fresh Kills on Staten Island, after which point it shipped its waste to other states and abroad and advanced its recycling programs. See Solid Waste Disposal Act, Public Law 89–272 (approved October 20, 1965, as amended through P.L. 117–58, enacted November 15, 2021); and Manevich, "A Timeline of Solid Waste Management."

harmful solid and hazardous waste on land and in waterways.[35] However, in landfills and wastewater, plastics and forever chemicals become suspended on timescales likely to surpass the existence of human societies, continually transforming the nature of our milieu and humanity's biochemical constitution.

Artist Noah Purifoy's reputation in assemblage emerged out of the *66 Signs of Neon*, a visionary 1966 traveling group exhibition originating at the University of California, Los Angeles, which included works Purifoy created from debris of the Watts riots. In 1965—the same year these legal negotiations between humanity and its waste were taking place—community action and advocacy touched off direct confrontation between the police state and local citizens after a traffic stop culminated in the attempted wrongful arrest of an African American teenager in Los Angeles. Large-scale looting and conflagrations in the streets emerged from decades of historical oppression and violence. As historian Daniel Widener has pointed out, this exhibition reflected "the complex vision

of community-oriented assemblage artists working in the context of social upheaval," as well as Purifoy's interest in the work of art's potential to foster mutual recognition and exchange.[36] One can find a connection between this tactile engagement with disused materials of human design and invention and Ukeles's urge to make physical contact in such an expansive way.

At the gates of the Joshua Tree National Park, where *Yucca brevifolia* (Joshua trees) proliferate at the intersections of the Mojave and the Colorado Deserts in Southern California, Purifoy effectively mined a new milieu at the far outpost of the Inland Empire's megalopolis, when, in 1989, he decamped to the desert. By pulling detritus out of the relentless human production and consumption cycle and transforming it into entirely new constellations, he launched his *Outdoor Desert Art Museum of Assemblage Sculpture* (1989–2004), a sprawling, experiential open-air museum filled with assemblage works (fig. 9). Reflecting the way that humanity continuously creates lifeworlds along with and alongside nonhuman subjects and elements in a mutual unfolding of creative energy, *Outdoor Desert Art Museum* amplifies these relations with its site visitors. Rejecting a narrowly conceived definition of sculpture, Purifoy built a range of structures and wayward configurations that germinate out from the parched sand. Artifactual in nature, Purifoy's sculptural works and the Joshua trees collectively engage their immediate milieu against the backdrop of the desert, as if to track and reflect upon humanity's engagement with the world. The Joshua trees' branches grow at angles once their ends freeze and bloom, then branch in response to local weather conditions.

Scholar Silvia Federici has pointed out that that when thinking of a "politics of the commons," we must first reframe our understanding of community: "Community as a quality of relations, a principle of cooperation and responsibility: to each other, the earth, the forests, the seas, the animals."[37] This proposition is a step beyond the conception of the commons that Garrett Hardin devised in the late 1960s, which forwarded a need for population control and separated out shared goods, materials, services, or spaces that one could neither demarcate as belonging to the public nor private sectors.[38] Butler cleaves this idea of redefining community and connecting it to several unique scenarios aboard *Dawn*'s spaceship. These new physical and conceptual arrangements between the body and its physical context—as a holistic ecology—take on greater significance,

36
Daniel Widener, "Studios in the Street: Creative Community and Visual Arts," *Black Arts West: Culture and Struggle in Postwar Los Angeles* (Durham, NC: Duke University Press, 2010), 170–71. See also Noah Purifoy, "The Art of Communication as a Creative Act," *66 Signs of Neon* (Los Angeles: 66 Signs of Neon, 1966), np.

37
Silvia Federici, "Feminism and the Politics of the Commons in an Era of Primitive Accumulation," in *Revolution at Point Zero: Housework, Reproduction, and Feminist Struggle* (Oakland, CA: PM Press, 2012), 145.

38
For an overview of the politics of the commons with respect to contemporary environmentalist thought, see Cathy Gere, "'Shovel-Ready': The Commons and the Climate Crisis," *Historical Studies in the Natural Sciences* 51, no. 4 (September 2021): 542–52. See also Garrett Hardin, "The Tragedy of the Commons," *Science* 162, no. 3,859 (1968): 1,243–48.

39
Butler, *Dawn*, 52.

40
Butler, 117.

even in the spaceship's nursery. The nursery contains botanical pods that serve as suspension chambers for holding human survivors in stasis after they were recused from Earth. As the Oankali explain: "It suits its care to his needs. It still benefits from the carbon dioxide he exhales and from his rare waste products. It floats in a bath of nutrients and water. These and the light supply the rest of its needs."[39] Embedded in the walls, the pods prolong human life through a biochemical process of exchange. Under suspension, the metabolism decelerates, and the body's systems harmonize with the ecology of the pods. Encountering humans as they emerge from their pods, Lilith learns that each chamber, too, is a symbiotic being. As Lilith notes, the vessels—by which the Oankali travel through interstellar space—"were like extensions of Oankali bodies."[40]

Connecting to spaces and contexts and connecting with individuals are resolutely existential acts, which reflects Butler's emphasis on these routine relations in everyday contemporary life. Must alliances and coalitions be similarly declared—or, following Serres, a "natural contract" drawn up—in order to recognize these relations finally? In *Dawn*, each act reflects a conscious decision—selecting kin, creating partnerships, building

Fig. 9 Noah Purifoy (American, 1917–2002), *Bowling Balls II and III*, 1994, with *San Francisco Oakland Bay Bridge*, 1997. Courtesy of Noah Purifoy Foundation.

cooperative activity, opening oneself to other humans and nonhumans, and creating new constellations of cells and DNA with other species. Looking back to the late 1970s, an ecology of care—an ecology of maintenance and caretaking that sought to foster a community's well-being—mobilizes the relationship in Ukeles's project between sanitation workers and the everyday lives of New Yorkers. As she has argued, *Touch Sanitation* was an "utterly public art injected into the city's bloodstream."[41] It was not simply the logistical efforts to engage thousands of municipal employees in the field, but it was these encounters and exchanges—only a fraction of which she documented—that instantiated the unseen intersubjective relations among and between people and things in the world and their waste. Reinforcing recognition by way of touch—an intimate gesture seemingly ancillary to the massive logistical apparatus of waste management—*Touch Sanitation* reminds us that these social practices are intensely political, and waste management may very well be the most important system of (urban) life. When viewed through this lens, the work instantiates the connection among persons and things in their environments. It opens questions like: Who exactly removes waste? Who has the privilege of having waste removed and not caring about who removes it? To what extent is the act of waste removal accorded value in a given system?

LIFEWORLDS

The works of environmental art that I have touched upon gesture us toward the nexus where symbolic activity meets the material world—as an integrated whole, shared as a commons. Amid heated debates about anthropogenic climate change and the depletion of natural resources, one might ask if technology is a means of speaking (and exchanging) in the same language as the Earth, or if—as many environmentalists would argue—it reflects humanity's inherent antagonism and "hierarchical thinking."[42] As scholar T. J. Demos points out, "this potential future defines new imperatives for an ethics of living and a politics of governing, and in turn provokes new challenges for contemporary art—particularly for those intent on participating in the ethico-political reinvention of life in the face of climate change."[43]

Octavia Butler teaches us that the arts of living are no passive activity. What if the seemingly non-sentient components of our planet communicated to us in forms that we might readily understand?

41
Ukeles, "Touch Sanitation."

42
Palwick and Butler, "Imagining a Sustainable Way of Life," 153.

43
T. J. Demos, *Decolonizing Nature: Contemporary Art and the Politics of Ecology* (Berlin: Sternberg Press, 2016), 33.

44
Serres, *The Natural Contract*, 39.

I thank Robert Wiesenberger,
Lyndsay Bloom, Anya Gallaccio,
Evan Neely, Anne Roecklein,
and Angela Anderson for their
discussions with me as I developed
this essay.

Her methods acknowledge human existence as embedded within the systems and materials on Earth, which "[speak] to us in terms of forces, bonds, and interactions."[44] Akin to artistic practice, Butler's novel imagines lifeworlds anew, acknowledging that our existence is embedded in and in relation to all things in nature. Life is the unfolding of creative impulses, subsisting and thriving, transforming a presumed static work of art into an evolving complex of signs and relations.

CHRISTINE HOWARD SANDOVAL

b. 1975, Anaheim, CA; member
of the Chalon Indian Nation; lives
and works in Vancouver

Christine Howard Sandoval's art narrates a history of the land. Her most recent drawings do this using water and fire, two elemental forces whose relative balance has defined the ecology of the artist's homeland in dramatic terms. To create her drawings, Howard Sandoval mixes water and plant fiber to create a pulp in which she embeds bear grass, a material long used in Native basket weaving. The artist then selectively masks the paper and scorches it to create an image in soot that alludes to the controlled burns that Native peoples have long employed as part of their stewardship of the land. Indeed, the wildfires that have devastated California in recent years are driven by climate change but exacerbated by a disregard for this Indigenous knowledge. At the Clark, one of Howard Sandoval's

Christine Howard Sandoval, *False Arch—The Span of An Opening (Hexaptych)* (detail), 2016. Adobe mud and graphite on paper, 120 × 52 in. (304.8 × 132.1 cm).

B. F. Sisk Dam and Gianelli Pumping-Generating Plant, Merced County, California, 1964. California Department of Water Resources.

carbonized drawings rests on a cedar stand on the floor. The paper, with its geometric latticework, assumes topographic dimensionality when draped over the frame.

Howard Sandoval's interest in the tension between Indigenous and colonial approaches to the land—namely, between reciprocity and domination—has drawn her focus to the built environment. Many of the artist's past drawings and sculptures have used adobe, an ancient building material composed of clay, sand, and soil. For the artist, the material evokes both her grandmother, who made adobe bricks, as well as the forced labor of Indigenous people who built much of colonial California. The artist's past drawings have abstracted the typologies of Spanish colonial mission architecture using a similar masking technique as the new works in soot.

Howard Sandoval's installation at the Clark includes a black-and-white aerial photograph on the gallery wall showing the construction of the San Luis Dam, located on the traditional land of the Amah Mutsun and the Yokut peoples. Dams have a history of interfering with Native ecosystems, whether by flooding harvesting

areas and homes or affecting the migration of fish. The lines etched into the earth during the construction of the dam, like those of the California mission system, reappear in Howard Sandoval's work in uneasy relationship to her organic media.

Howard Sandoval often includes archival or poetic material in her installations to acknowledge an ongoing process of research that uncovers forgotten or erased Native histories in California. "Indian Cartography," a poem by Ohlone-Costanoan Esselen writer Deborah Miranda appears beside the photograph. In it, Miranda describes a father who "opens a map of California" and "traces mountain ranges, rivers, county borders/ like family bloodlines." On the map he finds the valley of his youth, "drowned by a displaced river," and in his dreams he sees its ghosts. A haunting quality suffuses Howard Sandoval's works, too, which surface both memories of the land and premonitions of its future.

—MG

Christine Howard Sandoval, *Sketch*, 2023. Soot
on handmade paper, 24.5 × 15 in. (62.2 × 38.1 cm).

Christine Howard Sandoval, *True Arch—The Span
of an Enclosure* (diptych), 2020. Adobe mud and
graphite on paper, 52 × 40 in. (132.1 × 101.6 cm).

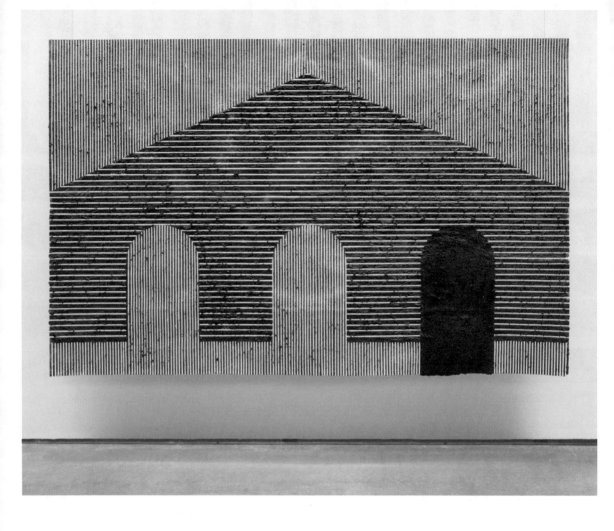

Christine Howard Sandoval, *Arch—A Passage Formed by a Curve*, 2020. Adobe mud and graphite on paper, 60 × 96 in. (152.4 × 243.8 cm).

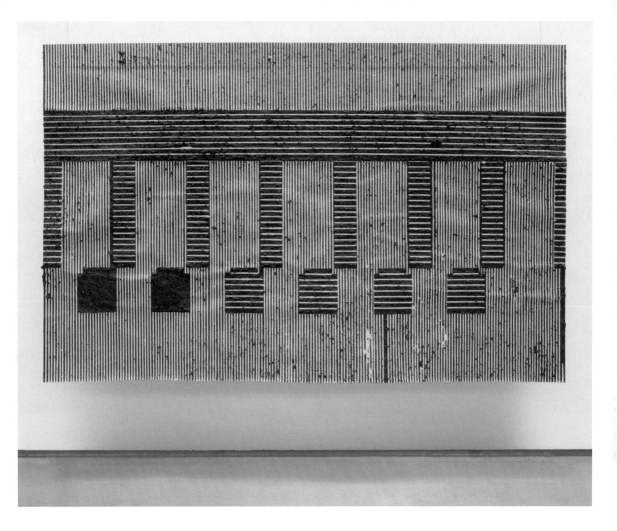

Christine Howard Sandoval, *Pillars—An Act of Decompression*, 2020. Adobe mud and graphite on paper, 60 × 96 in. (152.4 × 243.8 cm).

Christine Howard Sandoval, *Excavated Form—Boat*
(diptych), 2022. Recycled adobe, paper, colored
pencil, 30 × 22 1/2 in. ea. (76.2 × 57.2 cm).

Christine Howard Sandoval, *Memory of A Flood—Shasta Dam* (diptych), 2022. Recycled adobe, paper, colored pencil, giclee print, 30 × 22 ¹/₂ in. ea. (76.2 × 57.2 cm).

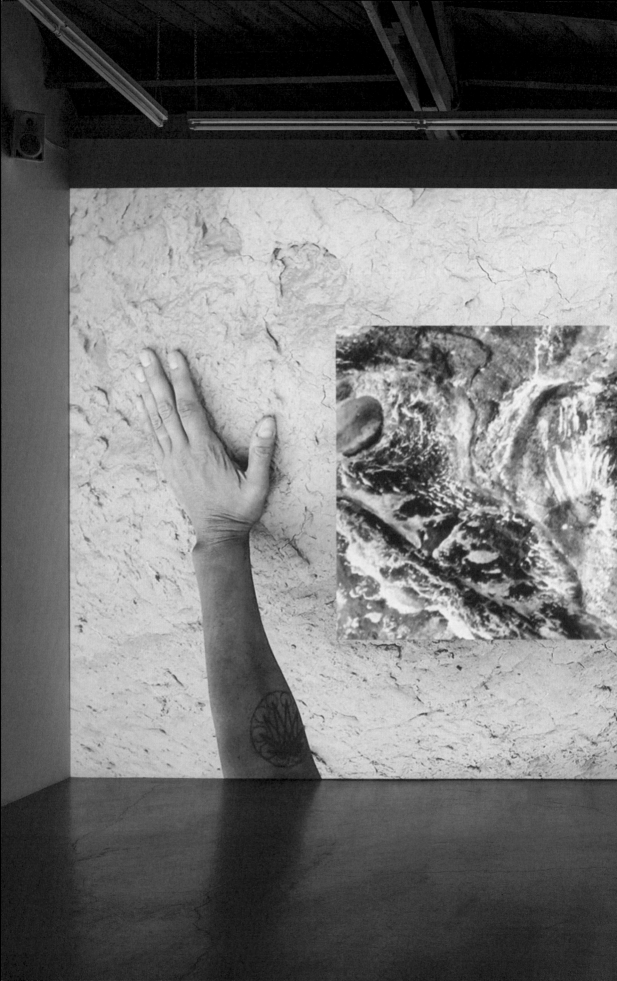

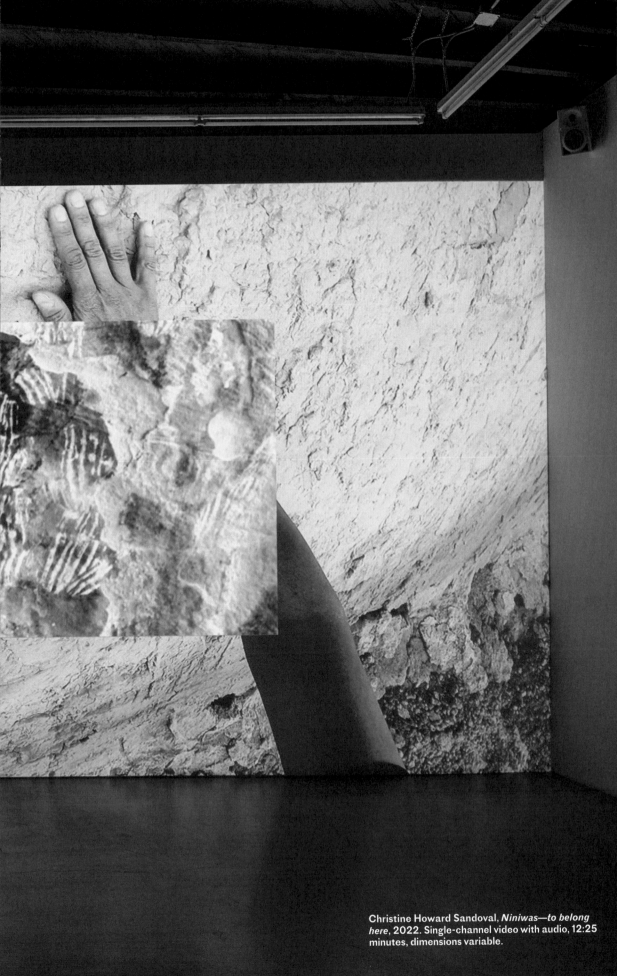

Christine Howard Sandoval, *Niniwas—to belong here*, 2022. Single-channel video with audio, 12:25 minutes, dimensions variable.

PALLAVI SEN

b. 1989, Bombay; lives and
works in Williamstown, MA,
and New York

Experimental Greens: Trellis Composition (2023) is a garden planted by Pallavi Sen, just outside the exhibition gallery, in which the artist's ecological ethics take shape across her woven jute lattices. Sen selected vegetables for planting like *Poona kheera*, a cucumber variant from Pune, India, and Hickory King dent corn, a variety from the American South that resembles the corn she grew up eating in India, which has since been replaced by American sweet corn monocultures. Besides evoking nostalgia, these variants were chosen for their heat tolerance, as the Berkshires region continues to warm due to climate change. In the process, Sen raises questions about belonging, for both plant and human migrants. Opposition to anthropogenically migrated plants bears rhetorical similarity to xenophobic

Harvesting chocolate runner pole beans, *Experimental Greens*, 2020.

Pallavi Sen, *Garden School*, 2020. Colored pencils on dotgrid, 8 × 10 in. (20.3 × 25.4 cm).

prejudices directed toward human migrants. By experimenting with South Asian vegetable variants that are better equipped than native ones to handle the local effects of anthropogenic climate change, Sen supplants ingrained dichotomies of belonging and foreignness.

Through trellising the artist constructs a perspective on time that's grounded in a self-reinforcing cycle of growth: as plants climb trellises woven from plant fiber and tissue, they strengthen and shape the very compositions that support them. Inspired by the importance of quotidian aesthetic choices in the gardening practices of her grandfather and mother, Sen's trellises allude to the adjustments gardeners make to attune themselves more nourishingly and less antagonistically to the lifeforms

around them. Similar to an earlier garden Sen built at Williams College, these trellises discourage groundhogs from feeding by offering them food along the perimeter but without erecting a strict, border-like division.

Elements made by the artist invite visitors to meditate on garden time. Along a walking path are a rain gauge and a sundial painted in fresco, each set atop ornately decorated ceramic tiles. Sen has explored her garden concepts and desire for close proximity to plant life in other media, such as watercolors and sculptural installations that feature a maximalist network of overlapping geometric shapes, gates, eyes, and plant material. On paper or in the field, Sen models alternatives to the separatist governance of plant and

human life embodied by monocultural, colonial, and extractive approaches to agriculture. The garden becomes a classroom, as with Sen's *Garden School* (2020) drawings, which illustrate a pedagogical model in which plant cultivation is the basis for a curriculum and academic calendar. Over the course of the summer, Sen's garden will be tended to by Williams College students, who will also document its changes online. At the end of the growing season, its vegetables will be harvested for a local food bank and its seeds will be saved and redistributed. With her approach to gardening, Sen invites visitors to sensitize themselves to changes large and small, on the way to a new ecological ethic.

—BYG

Pallavi Sen, *Garden School*, 2020. Colored pencils on dotgrid, 8 × 10 in. (20.3 × 25.4 cm).

Pallavi Sen, *Mango Harvest*, 2022. Watercolor on
paper, 18 × 14 in. (45.7 × 35.6 cm).

Next spread:
Pallavi Sen, *Abuela bendice el maíz*, 2023.
Watercolor on paper, 20 × 30 in.
(50.8 × 76.2 cm).

Pallavi Sen, *Grass*, 2017. Oil pastel on paper,
16 × 10 in. (40.6 × 25.4 cm).

Pallavi Sen, *The Night of the Storm When All the
Corn Fell*, 2022. Watercolor on paper, 18 × 24 in.
(45.7 × 61 cm).

Pallavi Sen, *Cut Flowers*, 2017. Oil pastel on paper,
16 × 10 (40.6 × 25.4 cm).

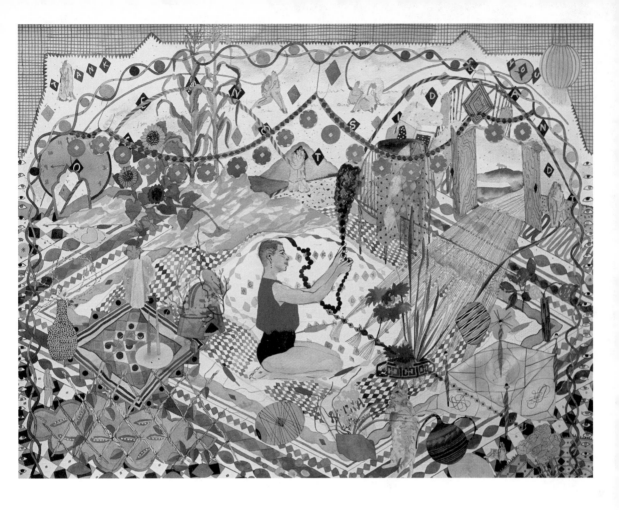

Pallavi Sen, *Sōfū Teshigahara's Arrangements*, 2021.
Watercolor on paper, 18 × 28 in. (45.7 × 71.1 cm).

Next spread:
Pallavi Sen, *Experimental Greens: Trellis
Composition*, 2023. Watercolor on paper,
20 × 30 in. (50.8 × 76.2 cm).

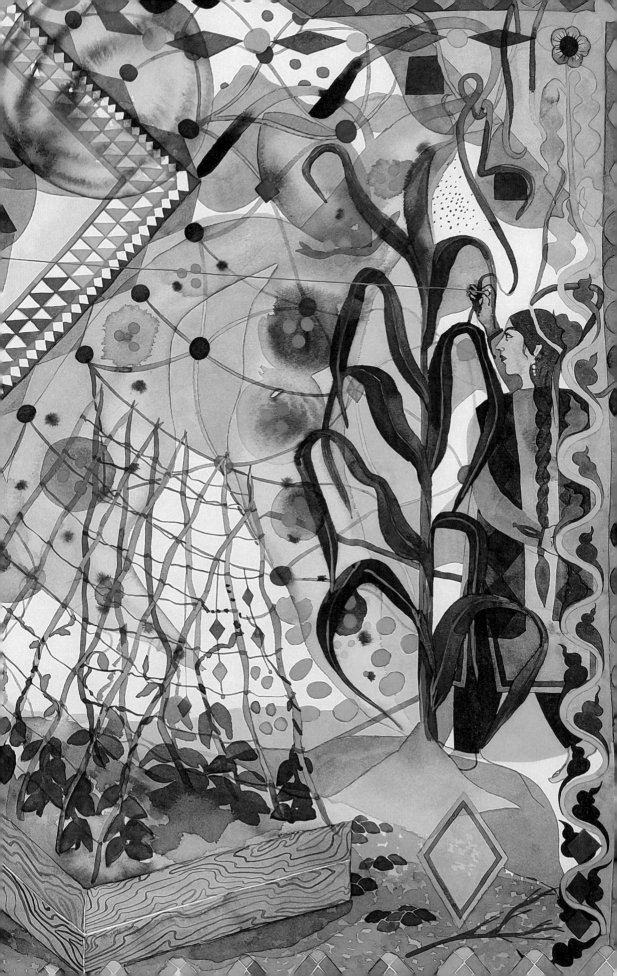

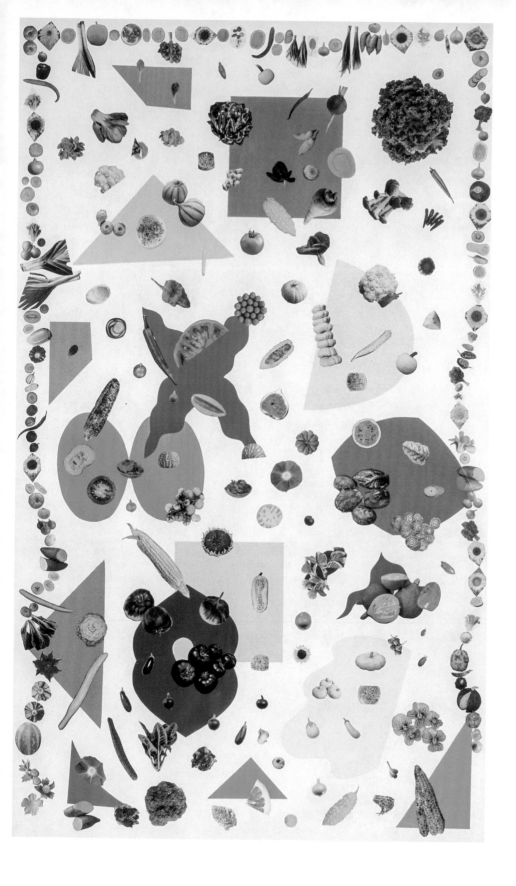

Ilana Harris-Babou and Pallavi Sen, *Deep Winter Seed Order*, 2022. Seed catalogue collage on paper, 59 1/2 × 36 in. (151.1 × 91.4 cm).

Pallavi Sen, *Clothes Drying by the Guava Tree,* 2022.
Watercolor on paper, 18 × 14 in. (45.7 × 35.6 cm).

KANDIS WILLIAMS

b. 1985, Baltimore; lives and works in New York

What at first appear to be decorative, potted plants in the gallery are, in Kandis Williams's installation, in fact intricate sculptures. The plants are artificial, and photographs of bare Black bodies are printed on or adhered to their plastic leaves. These sculptures also appeared in Williams's recent exhibition at 52 Walker in New York, titled *A Line*, a meditation on the history of dance as appropriation and erasure of Black culture, diagrammed in the artist's precise xerox collages of

dancers past and present. These were assembled on large, gridded sheets of paper and annotated with notes and lines—lines of embodied geometry, of force and flight, and of descent across geographic and cultural boundaries.

The fragmented, chiseled bodies in Williams's collages are those of professional dancers, while those in her plant works are models and sex workers. All of them contribute to an archive of representations of Black bodies in motion.

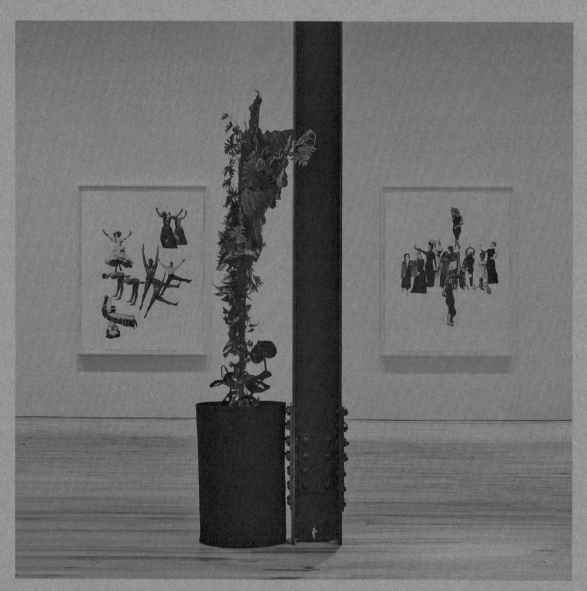

Kandis Williams, *A Line*, 2022. Installation view, 52 Walker, New York.

Kandis Williams, *A Field*, 2020. Installation view, Institute for Contemporary Art, Virginia Commonwealth University, Richmond.

In plant form, these bodies appear especially animate, emerging organically like blossoms. That so-called exotic plants native to tropical climes (palms, banana plants, monsteras, and others) are domesticated and made decorative in the white cube of an American gallery evokes histories of classification and exploitation, forced migration and adaptation. The paragraph-length titles of the works on view at the Clark are excerpted from the writings of dance historian Brenda Dixon Gottschild's and novelist Norman Mailer's midcentury musings on race in America.

"Plants," Williams has said, can be seen "as dynamic containers for speculative fictions." Some of these fictions were elaborated in the artist's first institutional solo exhibition, *A Field*, at the Institute for Contemporary Art, Virginia Commonwealth University, in 2020. At

its center, screened in a small greenhouse, was a video of a dancer twirling through steps recognizable as tango—a form associated with nineteenth-century Argentina and Uruguay, but which is Congolese in origin and traveled through the slave trade. Filmed against a green screen, a dancer is superimposed on the verdant fields of former plantations in Richmond, where the exhibition was held, as well as nearby prisons, where ongoing forced labor is all but indistinguishable from slavery. The dancer, entangled with an invisible partner, implicates viewers with their eyes.

Surrounding the greenhouse were more plants. Some sat on the floor or on stands while others appeared as floral arrangements in elegant vases, all of them also sprouting images. Here, the collages described a still broader range of labors—physical toil, performing arts, and sexual

performance mingle without hierarchy or distinction. "We are the commodity fetishized," Williams has said, invoking a mainstay of Marxism to describe the twinned exploitation and mystification of Black people in every aspect of culture. The erotic dimension is particularly important to the artist, for whom Jean-François Lyotard's 1974 *Libidinal Economy* is a touchstone. Lyotard's attempt to reconcile the structuralism of Marx's political economy with the drives of Freud's psychoanalytic theory courses through Williams's assemblages. By opening Lyotard's theories of desire to other forms of life, exchange, and value, Williams proposes a *libidinal ecology*, a more encompassing view of the past and the present.

—RW

*
Complete artwork information for the sculpture on pp. 177–79:

Kandis Williams, *Genes, not Genius: For jazz is orgasm, it is the music of orgasm, good orgasm and bad, and so it spoke across a nation, it had the communication of art even where it was watered, perverted, corrupted, and almost killed, it spoke in no matter what laundered popular way of instantaneous existential states to which some whites could respond, it was indeed a communication by art because it said, "I feel this, and now you do too." Virtuosity is bound to colorism, tokenism, trophyism, and the ruptures of interraciality on legacies of rape and social distortion of dark skin, reverse colorism is not real. The importance of dance in courtship and social gatherings is probably older than its use as recreation and entertainment*, 2021. Collage on artificial plant, fabric grow bag with moss, acrylic paint, plastic, 92 × 40 × 20 in. (233.7 × 104.1 × 50.8 cm).

**
Complete artwork information for the sculpture on pp. 182–85:

Kandis Williams, *Genes, not Genius: The overlying purpose is to address how the social production of biologically determinist racial scripts—which extend from a biocentric conception of the human—can be dislodged by bringing studies of blackness in/and science into conversation with autopoiesis, black Atlantic livingness, weights and measures, and poetry. A biocentric conception of the human, it should be noted up front, refers to the law-like order of knowledge that posits a Darwinian narrative of the human—that we are purely biological and bioevolutionary beings—as universal; elegance is elimination*, 2021. Collage on artificial plant, fabric grow bag with moss, plastic, 92 × 41 × 18 in. (233.7 × 104.1 × 45.7 cm).

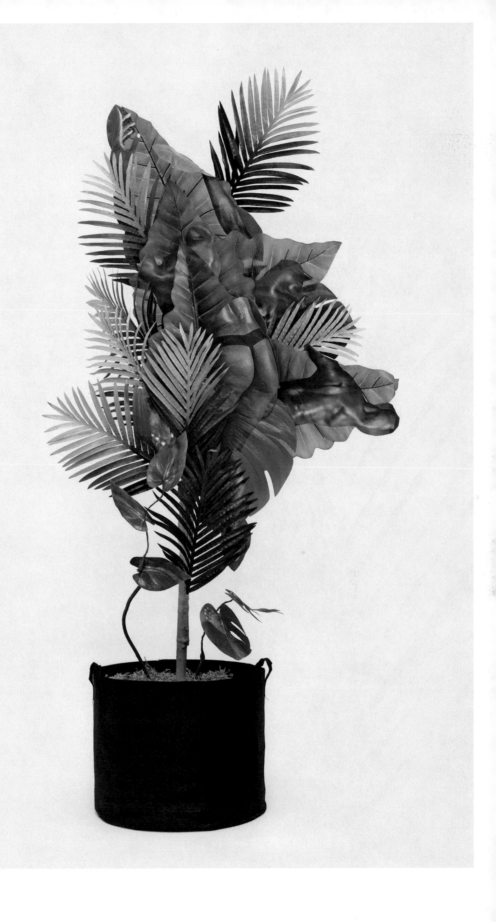

Kandis Williams, *Genes, not Genius: For jazz
is orgasm . . .* , 2021. *

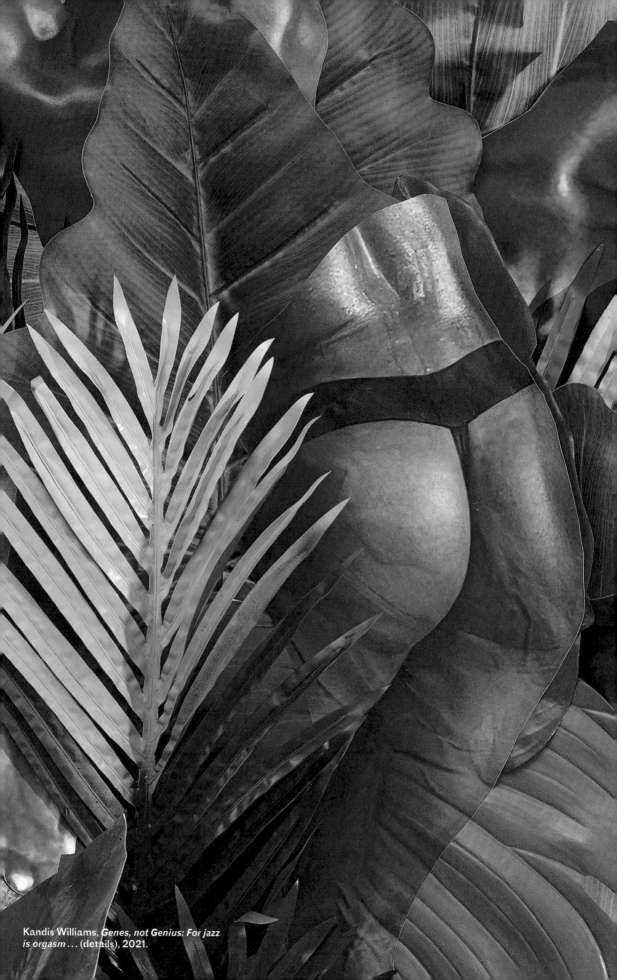

Kandis Williams, *Genes, not Genius: For jazz is orgasm . . .* (details), 2021.

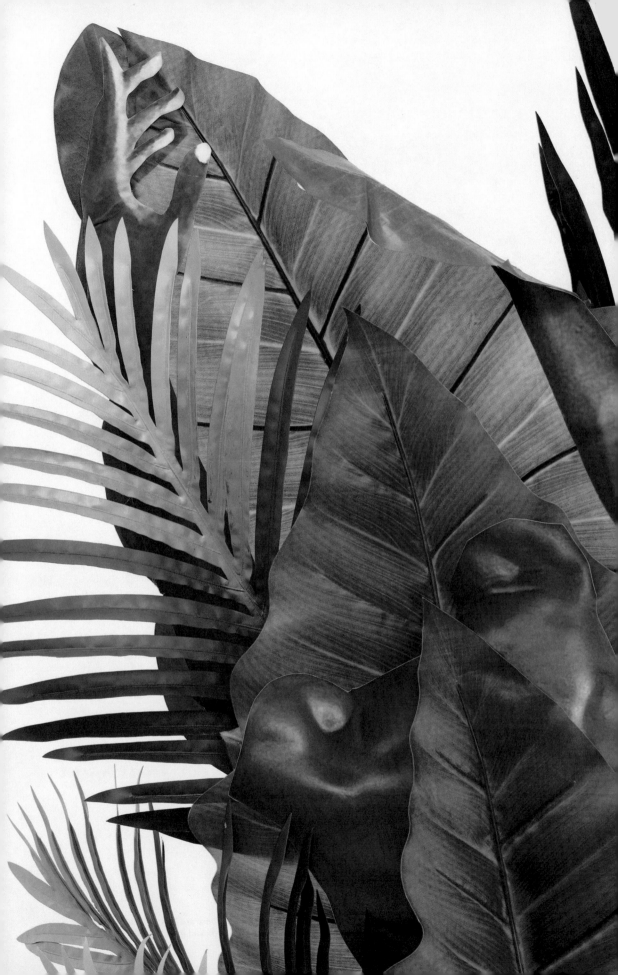

**Kandis Williams, *There are two sides to every Line*,
2021. Xerox collage and ink on paper, 66 × 52 in.
(167.6 × 132.1 cm).**

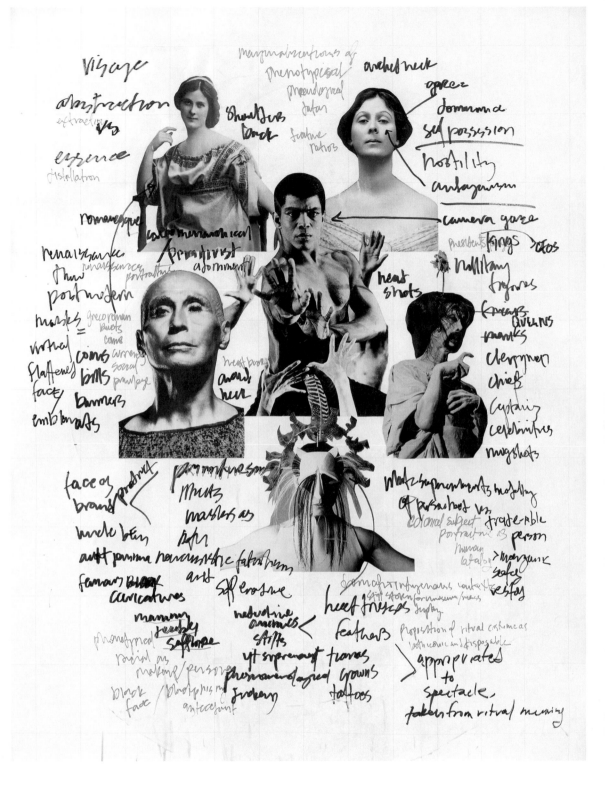

Kandis Williams, *Visage, use of portrait and mask from rulers to icons through Primitivism and phenotypical hierarchy*, 2021. Xerox collage and ink on paper, 66 × 52 in. (167.6 × 132.1 cm).

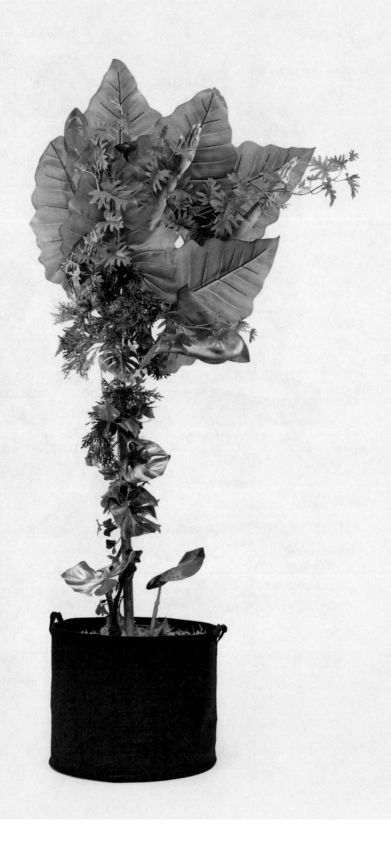

Kandis Williams, *Genes, not Genius: The overlying purpose . . .* , 2021. **

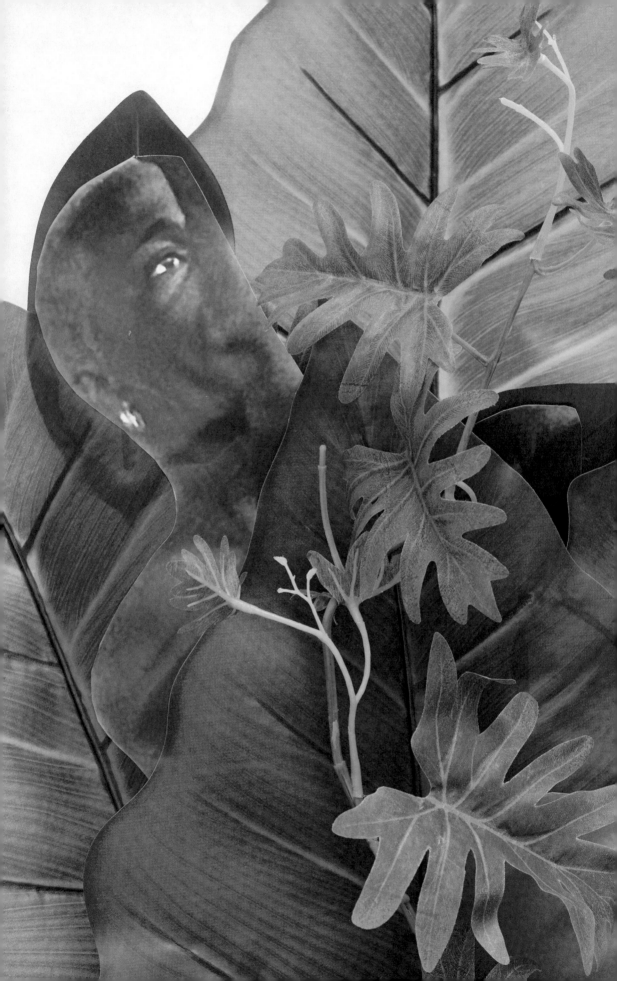

Kandis Williams, *Genes, not Genius: The overlying purpose...* (details), 2021.

Kandis Williams, *A Field*, 2020. Installation view, Institute for Contemporary Art, Virginia Commonwealth University, Richmond.

CONTRIBUTORS

Benet Y. Ge is a student at Williams College (BA '25).

Max Gruber is a graduate student at Williams College (MA '23).

Risa Puleo is an art historian of the early modern period who researches the history of museums, collecting, and exhibitions, specifically the colonial collection and display of Native American, African, and Oceanic objects. These priorities inform her practice as a curator of contemporary art. Her exhibitions *Monarchs: Brown and Native Artists in the Path of the Butterfly* (2017) and *Walls Turned Sideways: Artists Confront the Justice System* (2018) employed methods of institutional critique to unpack the museum's relation to settler colonialism and the carceral state. Puleo teaches at the School of the Art Institute of Chicago and is completing her dissertation at Northwestern University.

Robert Wiesenberger is curator of contemporary projects at the Clark Art Institute and lecturer in the Williams Graduate Program in the History of Art.

Alena J. Williams is assistant professor in the Department of Visual Arts and associate director of the Environmental Studies Program at the University of California, San Diego, where she teaches modern and contemporary art history and film, technology, and media studies. From 2018 to 2019, she was a faculty co-investigator of *Interrogating the Archive: Shared Research Methodologies at the Intersection of Aesthetics and Authenticity*, an interdisciplinary research group on archival experimentation and decolonial practices at UC San Diego. From 2010 to 2013, Williams curated *Nancy Holt: Sightlines*, an international traveling exhibition for the Miriam and Ira D. Wallach Art Gallery at Columbia University.

EXHIBITION CHECKLIST

EDDIE RODOLFO APARICIO
b. 1990, Los Angeles; lives and
works in Los Angeles

- *Hanging work* *
 2023
 Rubber, tree and paint residue,
 fabric, acrylic paint, various
 other materials

- *Wall work* *
 2023
 Rubber, tree and paint residue,
 various other materials

 *Complete artwork
 information was not available
 at time of publication.

Courtesy of the artist and
Commonwealth and Council,
Los Angeles/Mexico City

KORAKRIT ARUNANONDCHAI
b. 1986, Bangkok; lives and works
in New York and Bangkok

- *Songs for dying*
 2021
 Single-channel HD video, color,
 sound
 30:18 minutes

Courtesy of the artist; Bangkok
CityCity Gallery; Carlos/Ishikawa,
London; C L E A R I N G, New
York/Brussels/Los Angeles; and
Kukje Gallery, Seoul

CAROLINA CAYCEDO
b. 1978, London; lives and works
in Los Angeles

- *In Yarrow We Trust*
 2023
 Acrylic on canvas
 144 × 240 in. (365.8 × 609.6 cm)

- *Maternidad*
 2023
 Acrylic on canvas
 144 × 240 in. (365.8 × 609.6 cm)

- *Mamma Nettle Wheel*
 2023
 Acrylic mural
 150 × 150 in. (381 × 381 cm)

- *MI CUERPO, MI TERRITORIO*
 2023
 Corrugated plastic, wood poles,
 yarn, ribbon
 Dimensions variable

- *We Save Our Seed for the
 Following Season*

 *Cada sorbo de café será una
 bendición para ti (Tinti)*
 2023
 Jacquard weaving, UV acrylic
 printed cotton twill, paper
 flowers, wood
 Tapestry: 40 × 60 in. (101.6 ×
 152.4 cm); wood table: 4 × 70 ×
 27 (10.2 × 177.8 × 68.6 cm)

 *When You Take from Mother
 Earth You Can Give Back by
 Sprinkling Tobacco (Ella)*
 2023
 Jacquard weaving, UV
 acrylic printed cotton twill,
 wood, loose tobacco
 Tapestry: 50 × 36 in. (127 ×
 91.4 cm); wood table: 4 × 46 ×
 46 in. (10.2 × 116.8 × 116.8 cm)

 *Guardamos nuestra semilla para
 la próxima siembra (Caro)*
 2023
 Jacquard weaving and UV
 acrylic printed cotton twill
 42 × 60 in. (106.7 × 152.4 cm)

 *En función de la vida
 sabrosa (ABIF)*
 2023
 Jacquard weaving and UV
 acrylic printed cotton twill
 36 × 50 in. (91.4 × 127 cm)

 *Our Culture Is Based on
 Relationships with All Our
 Relatives (Meda)*
 2023
 Jacquard weaving, UV acrylic
 printed cotton twill, paper
 crowberries, wood
 Tapestry: 36 × 36 in. (91.4 ×
 91.4 cm); wood table: 4 × 57 ×
 43 in. (10.2 × 144.8 × 109.2 cm)

 Blooming (Akiko and Yuko)
 2023
 Jacquard weavings
 36 × 36 in. (91.4 × 91.4 cm)

Courtesy of the artist and Instituto
de Visión, Bogotá/New York

ALLISON JANAE HAMILTON
b. 1984, Lexington, KY; raised
in Florida; lives and works in
New York

- *Untitled (White Ouroboros)*
 2023
 Polyethylene terephthalate
 glycol, paint, resin
 42 × 28 × 8 in. (106.7 × 71.1 ×
 20.3 cm); 45 × 29 × 8 1/2 in. (114.3 ×
 73.7 × 21.6 cm)

Courtesy of the artist and
Marianne Boesky Gallery, New
York/Aspen

JUAN ANTONIO OLIVARES
b. 1988, Bayamón, Puerto Rico;
lives and works in New York

- *Fermi Paradox III*
 2019
 Echinocrepis rostrata shell,
 Cassis madagascariensis shells,
 Charonia tritonis shells, *Lambis
 lambis* shells, *Nautilus pompilius*
 shells, *Melo aethiopica* shell,
 Murex ramosus shell, *Syrinx
 aruanus* shell, *Triplofusus
 papillosus* shells, *Porifera*
 sponge, surface transducers,
 micro-speakers, stereo amps,
 coaxial cables, polyolefin-coated
 speaker wire, SD cards, media
 players, 24-channel audio file
 13:34 minutes, dimensions
 variable

Courtesy of the artist

**CHRISTINE HOWARD
SANDOVAL**
b. 1975, Anaheim, CA; member
of the Chalon Indian Nation;
lives and works in Vancouver

- *Ignition Pattern 1: Density*
 2023
 Soot, bear grass, handmade
 paper
 74 × 48 × 2 in. (188 × 121.9 × 5.1 cm)

- *Ignition Pattern 2: Victory
 Over the Sun (for Malevich)*
 2023
 Soot, bear grass seeds,
 handmade paper
 59 × 48 in. (149.9 × 121.9 cm)

- *Ignition Pattern 3: Memory
 of a Flood*
 2023
 Soot, bear grass, handmade
 paper, cedar
 40 × 83 × 20 in. (101.6 × 210.8 ×
 50.8 cm)

Courtesy of the artist